Drawing Projects
made EASY

Drawing Projects made EASY

Step-by-step instruction for beginners

BARRINGTON BARBER

ARCTURUS

ARCTURUS

This edition published in 2013 by Arcturus Publishing Limited
26/27 Bickels Yard, 151–153 Bermondsey Street,
London SE1 3HA

ISBN: 978-1-78212-058-2
AD002596EN

Printed in China

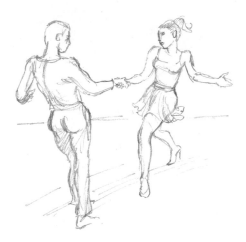

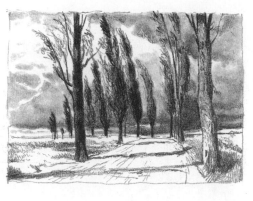

CONTENTS

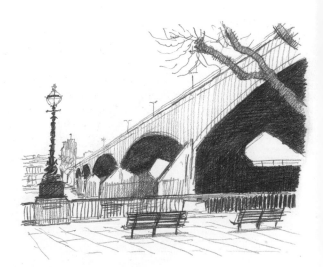

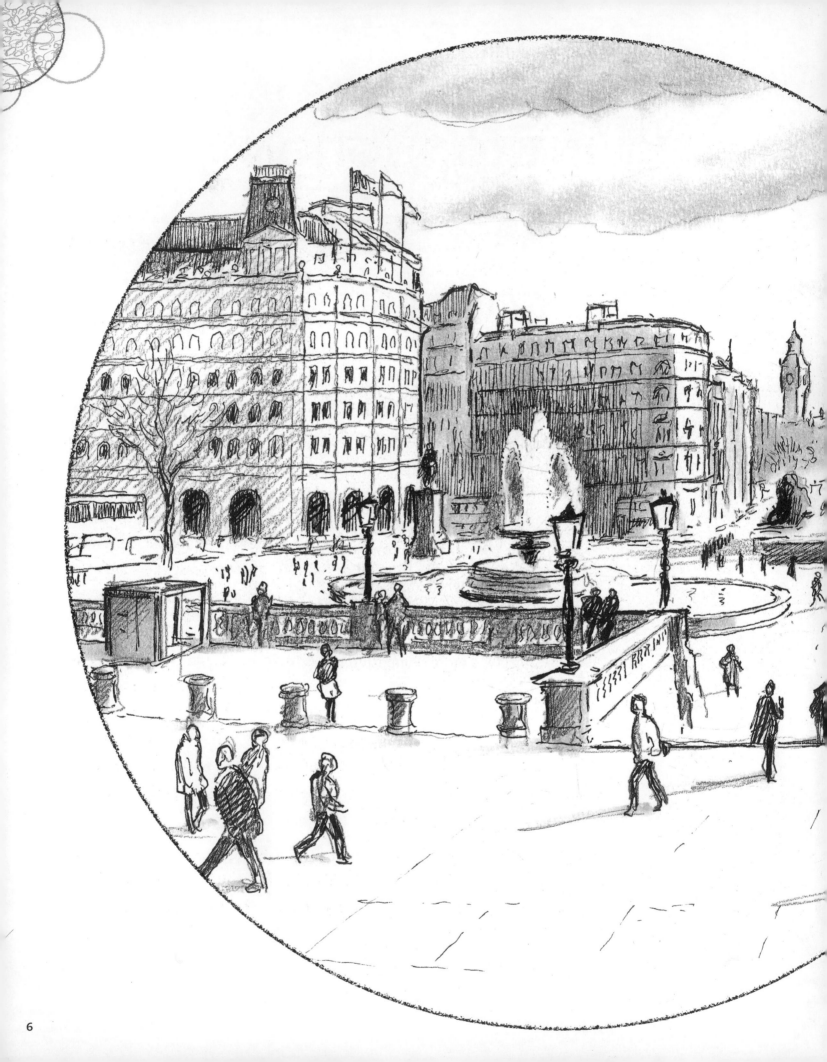

INTRODUCTION

This book presents a series of projects that teach the basic approaches to various areas of drawing, with the emphasis on preparing for a large final work that uses what has been learned on the way. However, there will be many preparatory pieces that will build your artistic skills for the future, so it's not just the final project that's important, but also the practices that will help you to reach it.

Drawing isn't a mystery – even if you haven't touched a drawing implement since childhood, you can start to draw with a systematic approach to this art form. Practice is the key to any discipline, and you always become good at what you practise often. Because of the particular form of this book, you can embark on it anywhere and make a reasonable effort to produce a picture. However, if you're an absolute beginner, it's worth noting that the easiest subjects are at the beginning and the more complex ones at the end. All the exercises are based on the way I have taught drawing and art for many years; there are of course many ways to teach art, but these are tried and tested methods that many artists have used in the past.

Each project is complete in itself, so that you can concentrate on one thing to give you a better chance of achieving a good result. However, you shouldn't be downhearted if at first the results don't look as skilful as the examples shown – remember that I am a professional artist who has had many years of practice. In fact you're never the best judge of your own work immediately on finishing it – put it aside and in a few days or even weeks you will have a better idea of your achievement.

So enjoy becoming involved with the creative process and you will understand why nobody ever reaches its end, which is what makes it so fascinating. There is always further to go, even if, like me, you have been drawing for a lifetime.

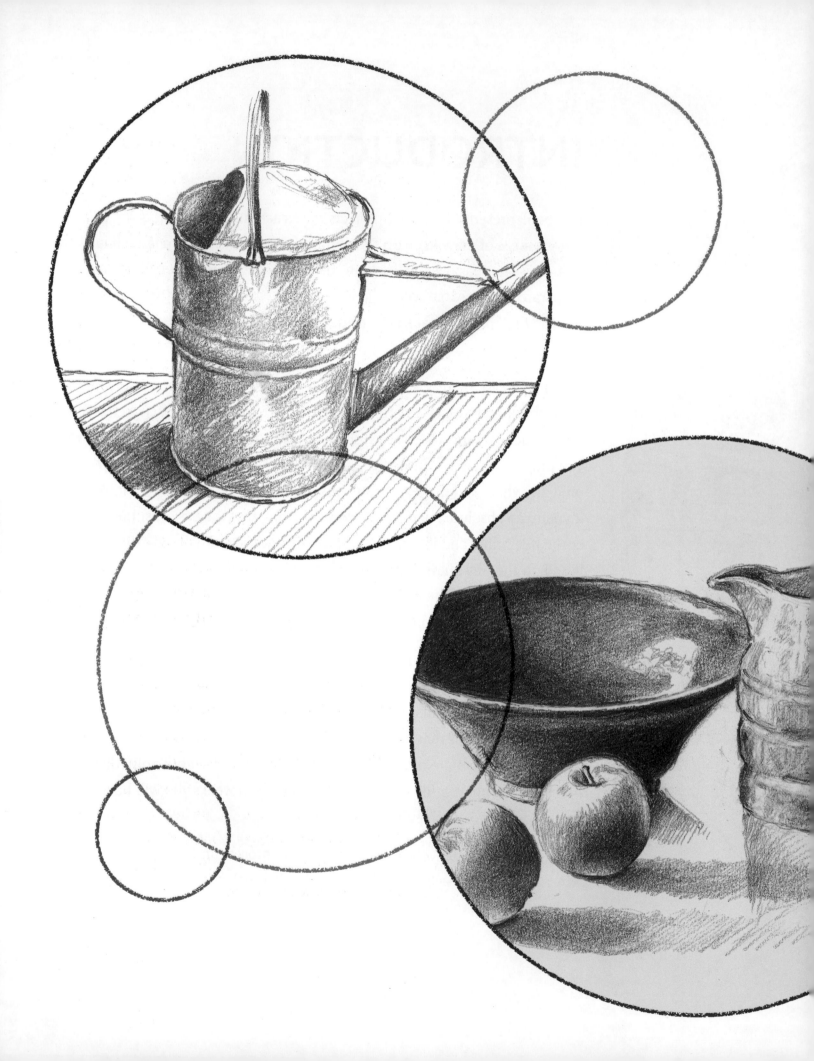

PROJECT 1: STARTING OUT WITH STILL LIFE

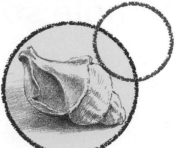

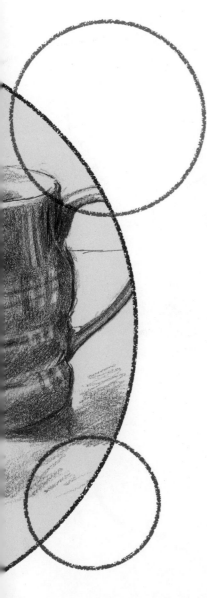

This part of the book starts with some straightforward drawings of mundane household objects so that you can practise your handling of shape, texture and tone. Many of the items you have around the house will have ordered, symmetrical forms and you need to be able to tackle those with confidence to make your interiors look convincing.

Once you've mastered the drawing of everyday objects in isolation, the next easy step is to try out your skill at putting together a composition of several objects and producing a still-life drawing. I have suggested a variety of obvious things for you to draw, but you can choose any subject that interests you.

In the later pages of this section I've included some larger and slightly more complex subjects so that you have something to get your teeth into if you find yourself steaming ahead in great shape. The main thing is to enjoy the process of drawing without worrying about how well or badly you're doing initially; just try out your skills of observing and then recording what you see, and you'll find that the more you do this the better you will get. I don't guarantee to turn you into an artistic genius, but with a little effort and the will to persevere you'll soon develop your abilities.

Simple still-life objects

Here we're going to build up to drawing a simple still-life composition, starting with some practice on straightforward household objects to help you tackle the problems that you'll discover. In these examples I've given you a variety of shapes, some easy and others more complex.

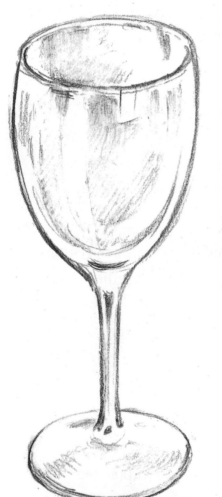

First I tried a tumbler and a wine glass, because they are easy to see through, and so you can see how the shape works. They are both centred on a central line, both sides being mirror images of each other. You could draw a vertical and draw each side of it, as I have done with the tumbler.

I've also drawn in all the tonal values, but before you embark on this do make sure that you have got the shape right.

Next I moved on to two solid objects, which are a bit more complex because of the projections on them. The first is a teapot, which I have drawn with the spout turned slightly towards me. So although the middle part of the pot is based on a central line, the spout and the handle are angled projections off that more balanced shape.

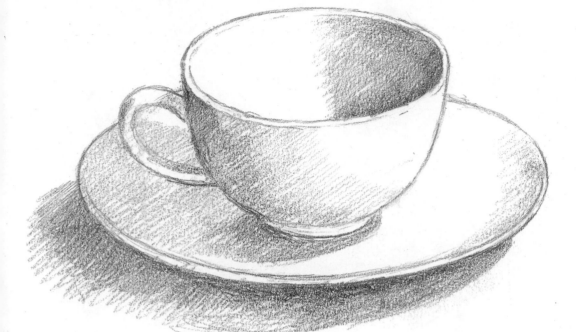

The next example is a cup and saucer, with the handle projecting to one side, and here you also have two objects that fit together to contend with. The shapes are gradually getting more complex to suit your developing skills.

Now a return to a glass tumbler – but this one has faceted sides in the lower half, which produces a more testing shape to draw. Again, as with all of these objects, the main thing is to get the shape right and only then go ahead with the shading.

A jug is the next object, but a curved one with a painted rim and handle to make things more tricky. Work on the shape first and then add the tone as before.

This pleasingly old and battered watering can is a little more complex in construction than what has gone before. It is your accuracy of perception that is going to be tested here, so this is good practice.

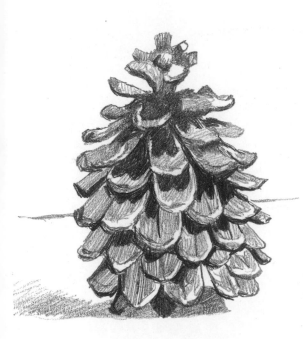

Unlike man-made goods, objects found in nature often have imperfections and unevenness in form. The trick with this pine cone is to make the tones very dark in the central shadows and lighter where the leaves don't overlap. Because of the variety in shape you don't have to worry if your drawing isn't exact.

In the case of a vase of flowers, you'll be drawing both natural and man-made things. Try to make the flowers and leaves look softer and more fragile than the vase.

Grouping objects

Now we're going to move on to groups of
objects – always trickier than single items
as you have to consider their relationship to
each other.

Start with an orange and lemon,
placing them in such a way that
one overlaps the other. This means
that you have to consider the size
of one compared with the other, as
well as the different shapes. When
you put in the tone, notice how the
shading on the lower part of the
orange helps to show up the shape
of the lemon.

Now try three objects – two apples and a pear. The space between
the apples is very narrow and causes a nice tension between their
shapes. The front apple overlaps the pear and helps to contrast the
two shapes. Here you are thinking in terms of a still-life composition.

Next we look at the very delicate natural shapes of three seashells. One is showing its hollow, while the next is seen from the reverse side, which helps to create a more interesting contrast. The third is of a different type, which adds more complexity to the arrangement.

This fork and spoon, both man-made objects, are rather precise and carefully shaped. The stainless steel they are made of gives very sharp contrast in the tonal range. To make it more interesting I have angled them away from my view to bring in a bit of perspective.

Larger objects

From small objects we jump to something much bigger, with the challenge of perspective thrown in. This is a normal, fairly straight up-and-down kitchen chair with a padded seat, seen in a strong angled light. The main thing here is to get the proportion between the seat, the back and the legs of the chair right. This can be quite time-consuming, but if you don't take trouble over it the chair will look either unwieldy or out of balance.

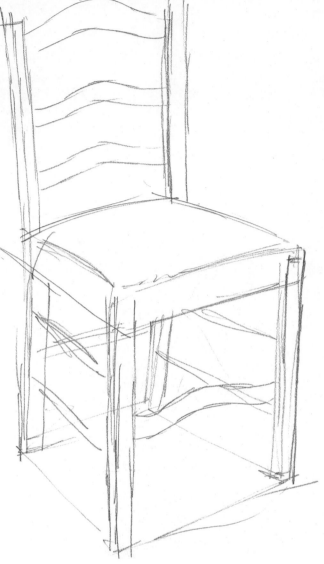

When you are drawing an object such as a chair which has a regular cuboid structure, it's advisable to sketch the block-like shape first to make sure that the perspective of the structure is clearly seen.

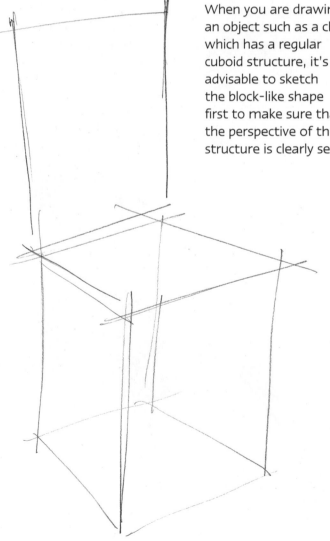

Then draw out the main structure of the chair so that you have a good basis on which to do your more detailed drawing. Look at the perspective of the shape of the chair and try to get all the parts correctly placed.

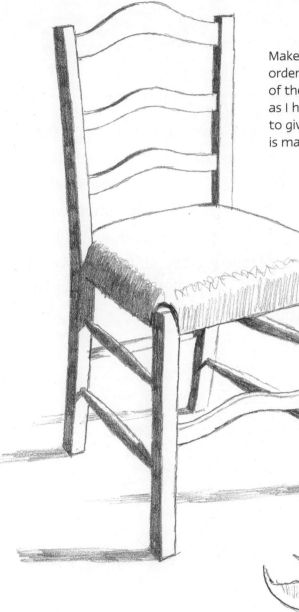

Make the shadows quite strong in order to give a sense of the rigidity of the construction. Draw the chair as I have, set at an angle to you, to give more sense of the way it is made.

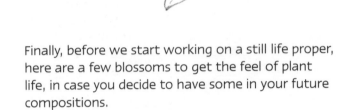

Finally, before we start working on a still life proper, here are a few blossoms to get the feel of plant life, in case you decide to have some in your future compositions.

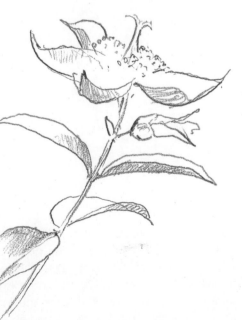

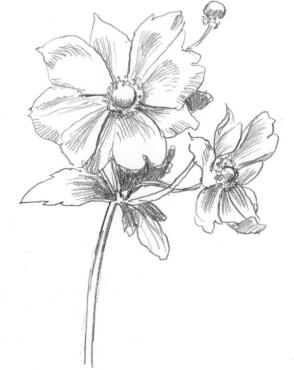

PROJECT 1

Simple still life

You can decide for yourself what you want to draw for your own first still life or follow my example given here. To start with, I looked around my living room for likely objects and picked up a bowl with some fruit in it. I felt that including all the fruit might be rather complex, so I removed it except for two apples, which I placed on a table by the bowl. I placed a jug on the table to add a more vertical shape to the composition and started moving the pieces around to see what might look interesting.

The light was coming very strongly from the left-hand side of the composition, so it was relatively well lit. I put the jug in a position that just appeared to clip the edge of the bowl from where I was sitting. I moved the two apples so that they were very close together, but not quite overlapping. I thought that this would give some tension to the arrangement.

▲ After assessing the relative sizes of the objects, draw a fairly loose outline of each one, making sure they are in the correct relation to each other and the main shapes are accurate. Use an eraser to correct any mistakes until you are satisfied that you have arrived at a good likeness. When you've had more experience you'll be able to take the accuracy of the drawing much further, but for the moment go by your own perception as to the quality of your drawing. The nice thing about drawing is that you never arrive at a point where you can't improve on your skill – that's what makes it so engrossing.

◀ Now put in as much of the shading as you can, but all in a fairly light, even tone. This will train your eye to see the whole shaded area rather than doing each piece separately. While doing this I discovered that the light was in fact coming from two directions, most strongly from the left, but also from behind the objects. This meant I had to make a decision about where the emphasis would be when I put in the stronger tones; you can make things easier for yourself by making sure that the light is only from one direction.

▲ The next stage is where the whole composition starts to gain some feeling of convincing dimensions. Often the best way to proceed is to put in the very darkest tones over the general tone already there, so that you get some idea about how much you will have to grade the tones from darkest to lightest. All the in-between tones are variable depending on how dramatic you want the drawing to look. With greater contrast there's more drama, and with gentler contrast there is a more subtle feeling of depth. In this drawing I've left a bit of drama in the lighting without becoming too melodramatic.

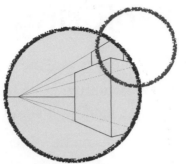

PROJECT 2: **THEMED STILL LIFE**

Themes in still life are there to create a kind of narrative in your drawing that can add an extra dimension of interest to the picture. Whether the themes are quite subtle or very obvious, there's a certain playful interest in composing objects to give a storyline to the still life. The theme can be a wide-ranging idea, such as travel or sport, or you can narrow the focus to something more precise, such as a *vanitas* theme or the preparation of a meal.

Sometimes finding a particular object that you want to draw in context pushes the arrangement in a special direction; noticing the attractive shape of a child's tricycle led me to a drawing of toys as a theme, for example. Thinking about drawing very small objects prompted me to draw the contents of a pocket or handbag.

So you can be as inventive as you like in your choice of a theme, because it will add quite a lot of interest for the viewer. Themes can have quite an obsessive quality about them, but this is part of their charm, they also act as an example, while a single ball prompted me to collect a range of items relating to sport.

Exploring themes

There are many themes which you can use in still life, and in this chapter I have suggested just a few of them to give you a starting point. Choosing a theme helps to focus the mind of the artist, because it limits the type of object that can be used. Also the viewer can find satisfaction in being able to recognize the connection between the objects. In a way a themed still life is like a narrative; it tells a story about a particular subject, which adds a point of interest that otherwise would not be there.

The first drawing shows the different forms of material that you can incorporate in a composition to show off your abilities in rendering texture. Here we have a basket with a wooden spatula leaning against it, a ceramic jug, a wine glass, a cloth tea towel and a metal saucepan. So in one still life you can show six or more materials, and if you are dextrous enough they will make an interesting picture.

A sporting theme might be to your taste, and you can choose to illustrate a sport that you are interested in. I found all sorts of sports equipment at a local school: flippers and a snorkel, a cricket bat and ball, football shoes, boxing gloves and even fencing swords! Having made my drawing, I realized that I had become carried away and included too many objects, spacing them too far apart to make a good composition.

Next is a still life of children's toys, including a tricycle, a toy cat, a plastic duck, a toy car, a set of interlocking jars and a painted egg. There are many other toys that you could show in a composition like this. For example stuffed toys and dolls have a strong hold on the imagination, and the contrast between a large hard object like the tricycle and a woolly teddy bear would give a maximum textural range.

Here the theme is travel, with a suitcase, a rucksack, a soft bag, some boots and an overcoat. The objects look as though they are just about to be picked up and stowed in a car to set off somewhere.

A very popular theme for more traditional still-life artists is that of cooking. Here we see various items that may be used in the creation of a cake or pudding, or just as part of a larger meal. Again the variety of shapes and textures gives you a chance to show how well you can draw.

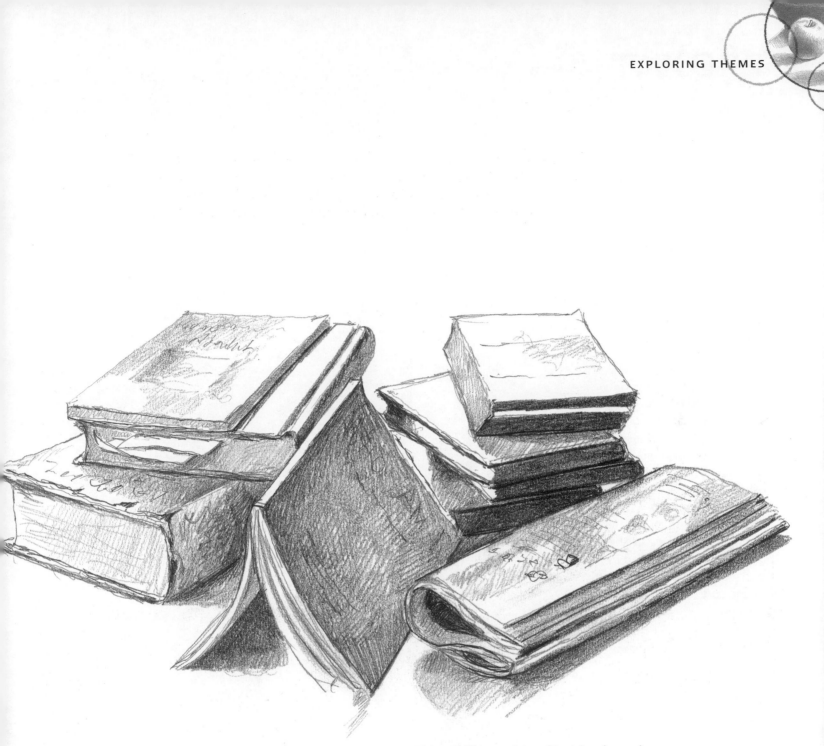

This still life consists of just books and paper and needed to be arranged quite carefully to make an interesting composition. It looks easy but in fact is quite difficult to draw convincingly.

My theme here is the end of a sumptuous meal, with objects such as a decanter, glasses of half-drunk wine, bread, a cheeseboard, nuts, plates and discarded napkins suggesting that a good time has been had by all.

▷ This project is one in which I could control my set-up easily, selecting just the end of a table and a couple of chairs that suggest a much larger expanse. The background could be quite dark, evoking a big room with the lights low, since all the diners have left. I began by putting down a rough idea of the sort of setting I had in mind.

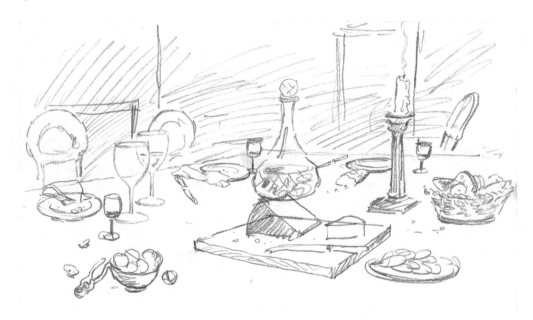

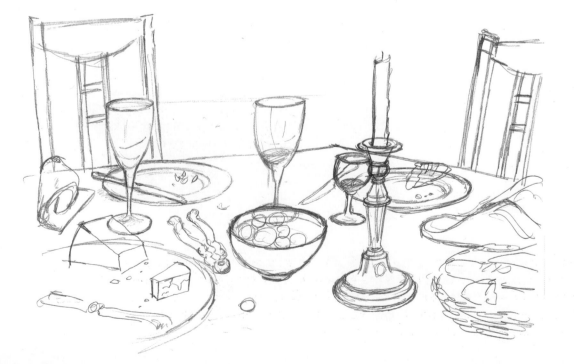

◁ Next, I gathered the items to put on the table-top and made some preliminary set-ups to try different compositions. I made separate drawings of some of the objects to get an idea of how I would treat them, then drew up a fairly well-worked-out version of how my final composition will look.

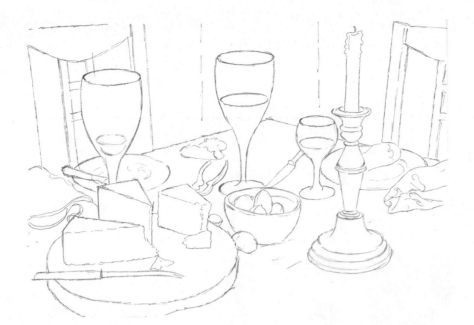

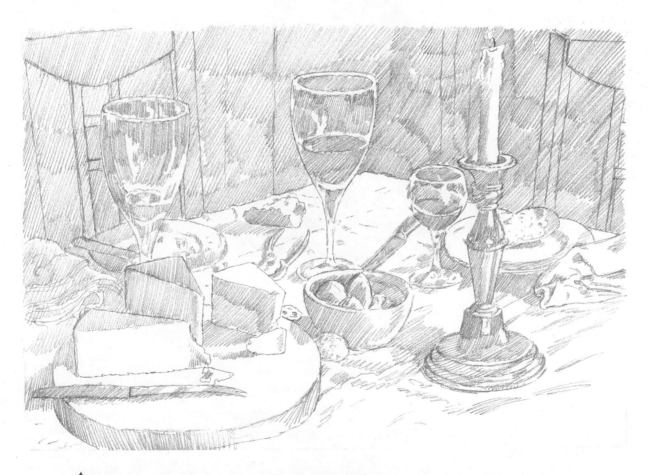

Having by now made up my mind as to the way I was going to draw the picture, I carefully produced a line drawing of the composition. It shows a close-up view of a corner of the table top, covered with a cloth. On it are two side plates, some nuts and a nutcracker, a candlestick with a snuffed-out candle, glasses, knives, a cheeseboard and slices of bread. A couple of discarded napkins by the plates give the feeling that the diners have just left.

The next step was to work over the whole drawing, putting a basic layer of tone on all the areas where there would be some shadow. Most of the background would be quite dark in the finished drawing to help throw forward the objects on the table. I left the paper white for all the brighter edges of the glasses and metal objects, so that the highlights would provide tonal contrast.

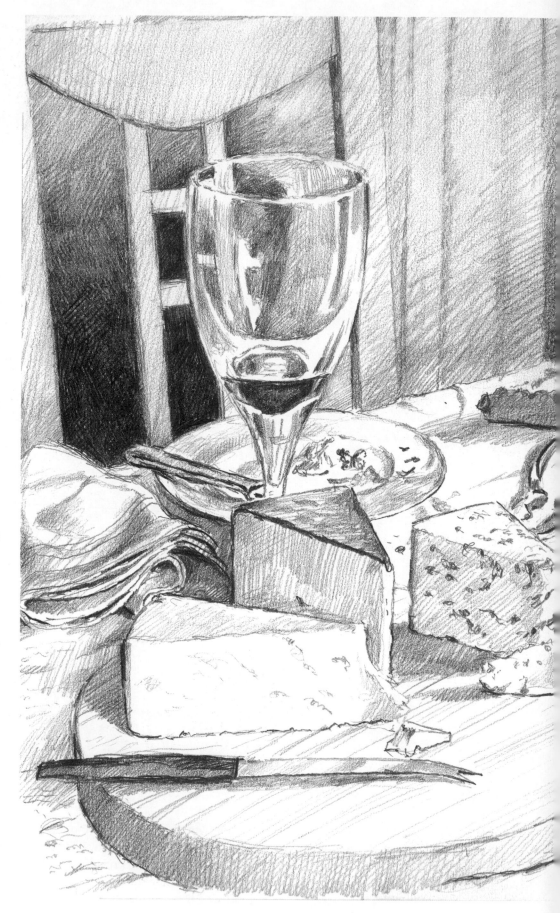

▶ In the last stage, I worked up all the varieties of tone so that the solidity of the objects and their materiality can be seen. It is a good idea to put in the very darkest tones first and then work in the variations between the darkest and lightest, as this makes it easier to balance the tones to the best effect. In my example the darkest tones are in the background depths and the dark wine in the glasses, while the knives and candlestick also have very dark areas to contrast with the bright highlights. The overall tonal contrasts in the drawing help to give the objects and the composition depth and substance.

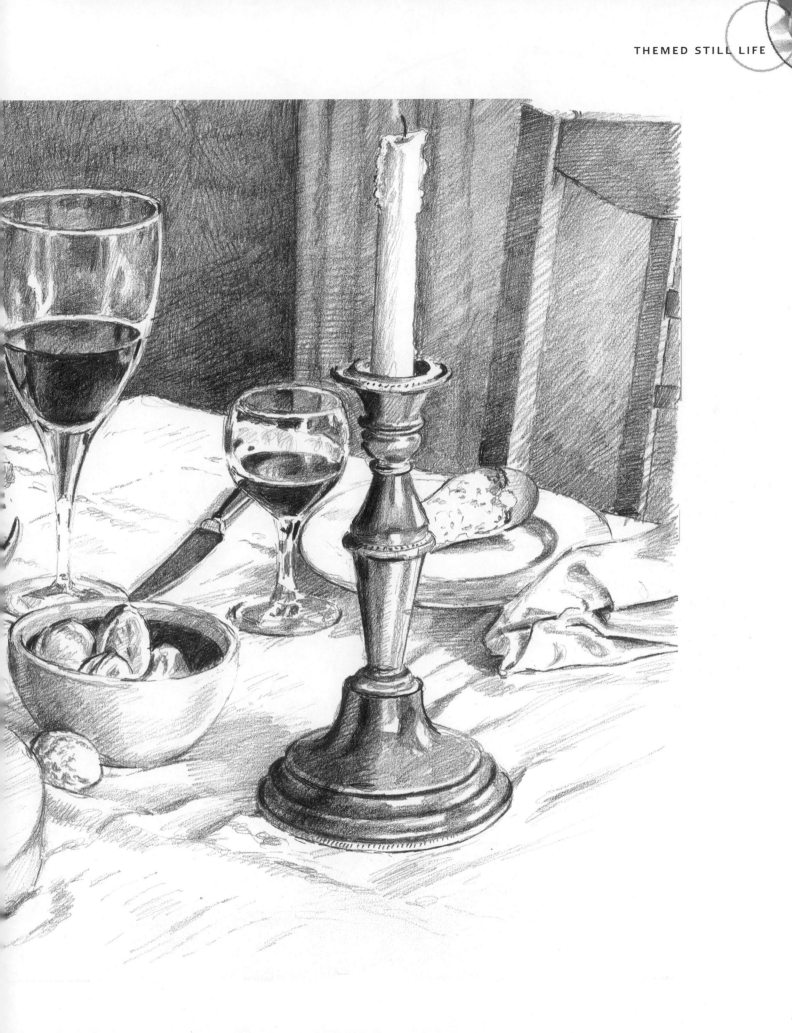

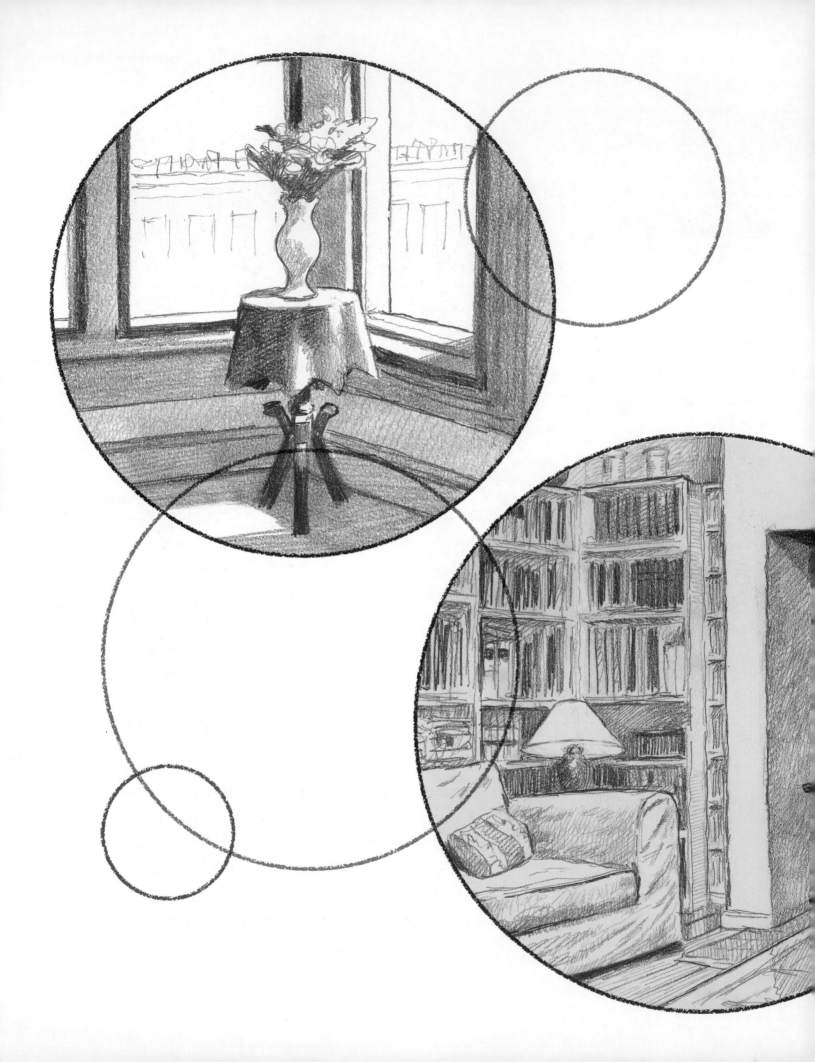

PROJECT 3: INTERIORS – AROUND THE HOUSE

Drawing interiors calls for subtle handling of tone, as otherwise the viewer will have difficulty in understanding how the objects within the room relate to each other. In this chapter you'll see how tone can be shown in both ink and pencil so that the various elements sit comfortably in the space, with consistent handling of the light source.

Making the interior of your home your subject is the logical progression from the simple still-life work that you've done so far. You'll find that sometimes your drawings may appear rather awkward until you've discovered how best to tackle a view of a room and its furniture, but don't let that put you off – all artists have to go through this process of deciding exactly how much to show in a drawing. It's the beginning of understanding how to compose the world about you in order to give the most interesting view of it.

Don't exclude untidy details that sometimes clutter a room – the everyday mess of living is part of the way a picture can tell a story that goes beyond just the simple perspective of an interior. And speaking of perspective, it's here that you'll first need to think about this in order to help bring more depth and space into your drawings, making your interiors look convincing and full of interest.

Drawing around the house

I started this exploration by walking around my own house and drawing small areas of the rooms from different angles and from both a standing and sitting position to give me different eye levels. Some views are quite restricted and others more expansive, but they demonstrate that even in your own house you'll find many possible subjects for a drawing. Don't worry too much if the results are rather uninteresting as pictures – the point is to practise drawing some larger objects and spaces, and also to introduce some perspective.

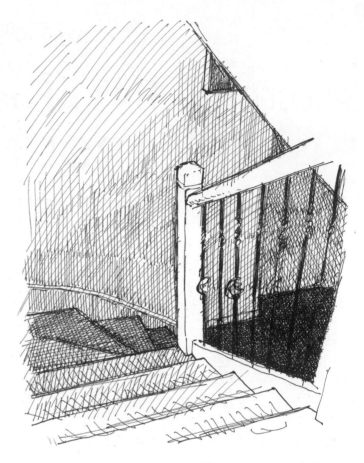

My first view was of an open sitting area at the back of our house. The perspective is shown mostly in the lines of the floorboards and in the shapes of the dresser and window. The cupboards and chairs give scope to achieve a three-dimensional effect to add to that given by the perspective.

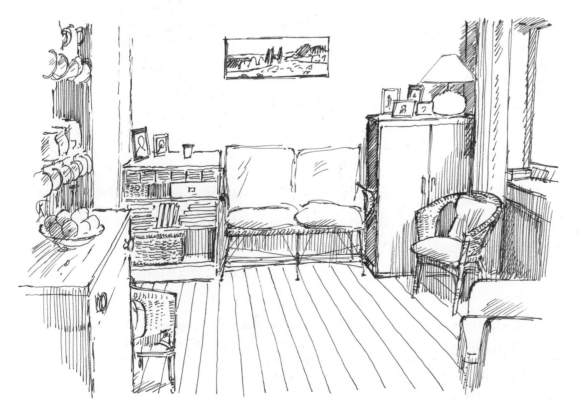

The next area I chose (above) was tricky because it was halfway up the stairs and the perspective view was slightly unusual. One way to check out your own basic drawing is to take a photograph with a digital camera and note the angles on the screen of the camera to check your drawing by. The top end of the stairs was well lit, while the bottom stairs in the hall were much darker in comparison. This helps to give some feeling of depth to the composition, with the banister rail sharply defined against the gloom.

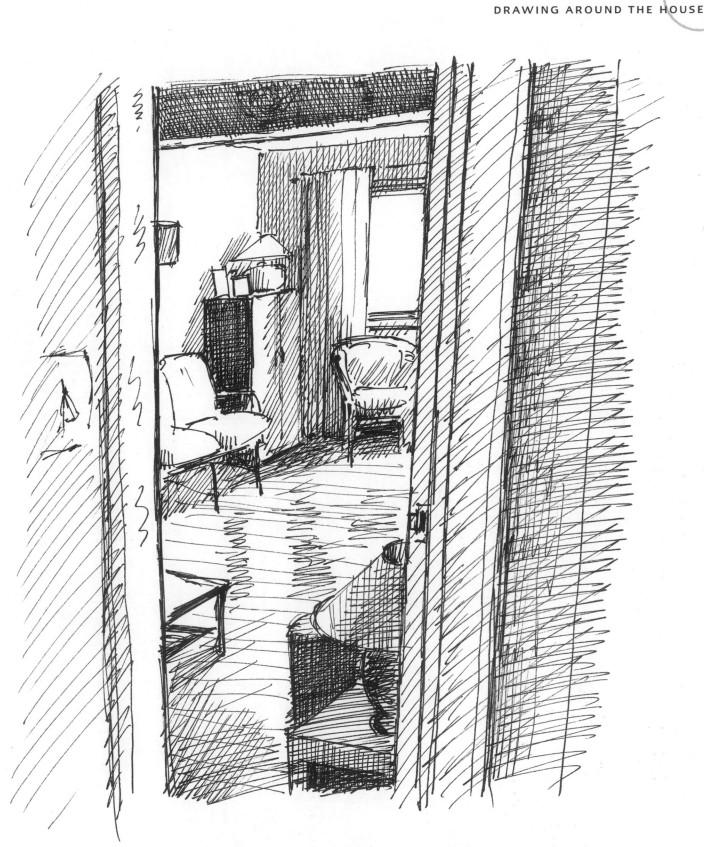

Then I took a view through an open door looking towards the windows at the back of the house. I could mainly see bits of chairs and tables, with the bright light of the window seen through the dark surround of the door jamb. This always makes for an intriguing quality in the picture because it seems to be revealing a secret view.

For the next view, I have done a perspective construction to give you some idea as to how the dynamics of the picture will work. This can be done with any interior, although some have more obvious perspective than others. This one, which gives us a view down the length of a table, does demand that perspective is taken into account. We'll be looking at how to construct perspective in more depth in the next project (see pages 48–9).

In the final drawing you can see how the perspective works, with the table cleared and the floorboards receding towards the windows. The light coming in from the windows and bouncing off the tabletop contrasts with the darker, shadowed areas of the walls.

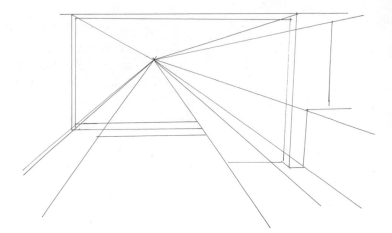

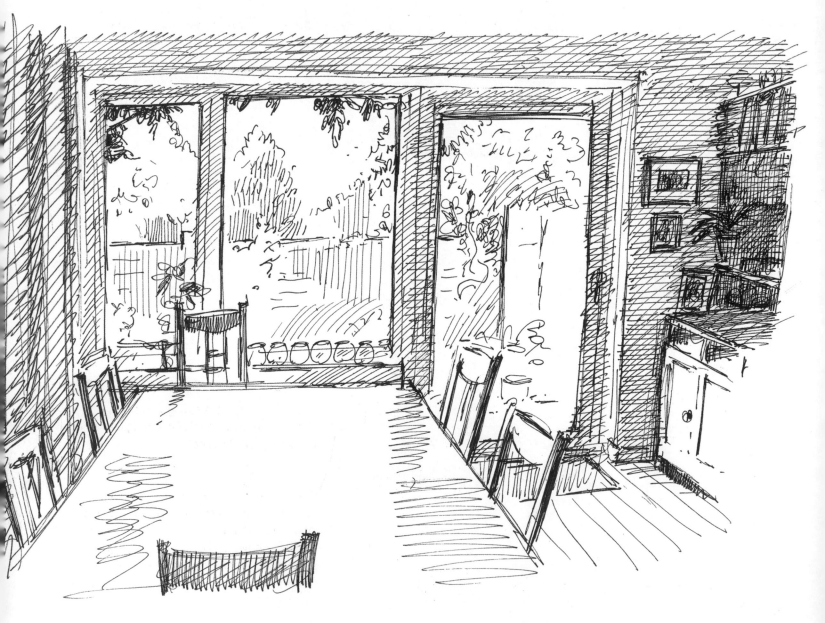

Here is another perspective diagram to show how the construction of the scene gives more depth to the finished picture of my kitchen – another area which is often the site of interesting accidental still life.

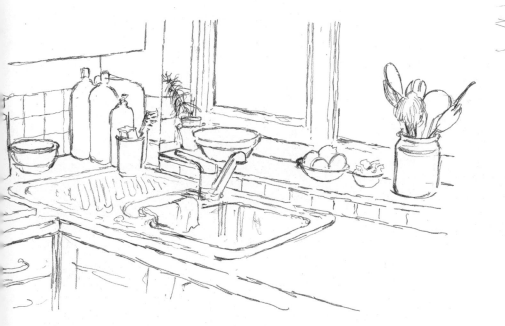

This is the view of the sink and all the paraphernalia surrounding it, as in most kitchens. It might have been even more interesting had there been some washing up piled up on the side of the sink.

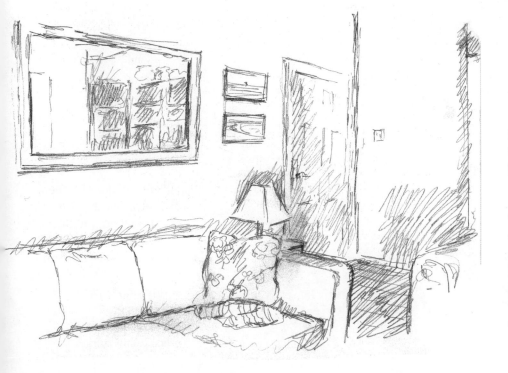

Here the perspective diagram shows how the construction of the drawing below is in fact relatively simple.

This drawing is a view of a sitting area with a mirror on the wall and the corner of a sofa with a door behind it. It isn't highly significant, but there is a small amount of perspective to be observed in the shapes of the mirror and the pictures on the wall.

Drawing an interior

So now we come to the point where we have to put our ideas into practice, and I have chosen for my example the sitting room of the house, with its woodburning stove, bookcases and television set.

▷ The first step was a perspective drawing of the structure of the room from where I was seeing it. As so many of the parts of the room are rectangular in shape, it was not too difficult to produce a perspective. This is a very ordinary room, with no pretensions to grandeur or eccentricity.

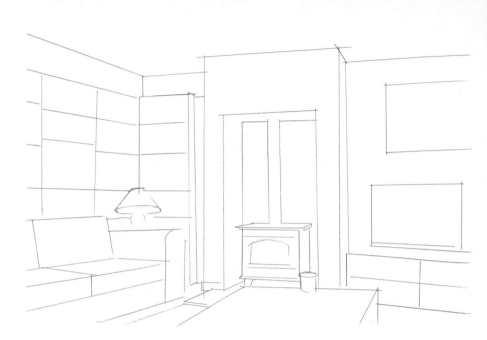

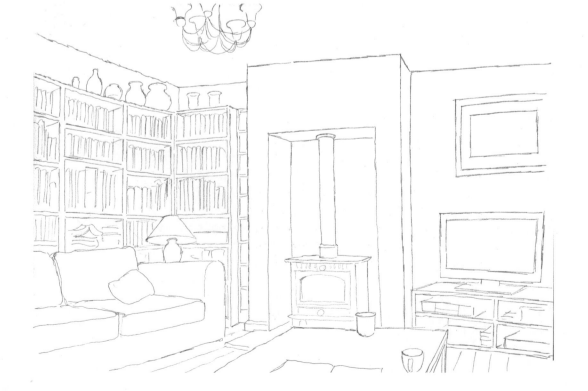

◁ Having got the feel of the perspective, I could now go ahead and start to draw in all the main shapes of the furniture, walls, ceiling and floor, keeping the outline as simple as possible without missing anything.

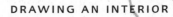

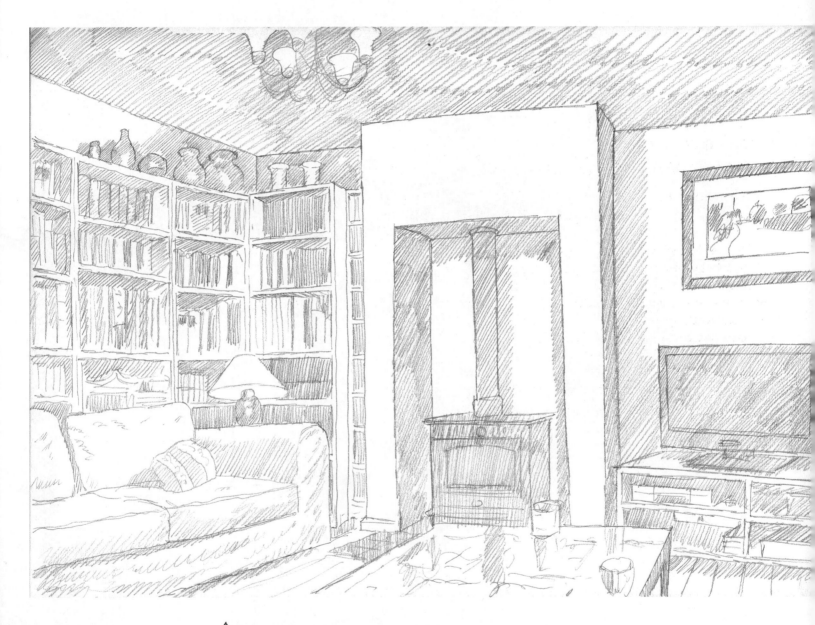

▲ Having arrived at a point where I was satisfied with the accuracy of the drawing – not without a few erasures of misjudged marks – I could now go ahead with the next stage, which was to put in all the areas of shadow in one light tone. This started to give body to the scene.

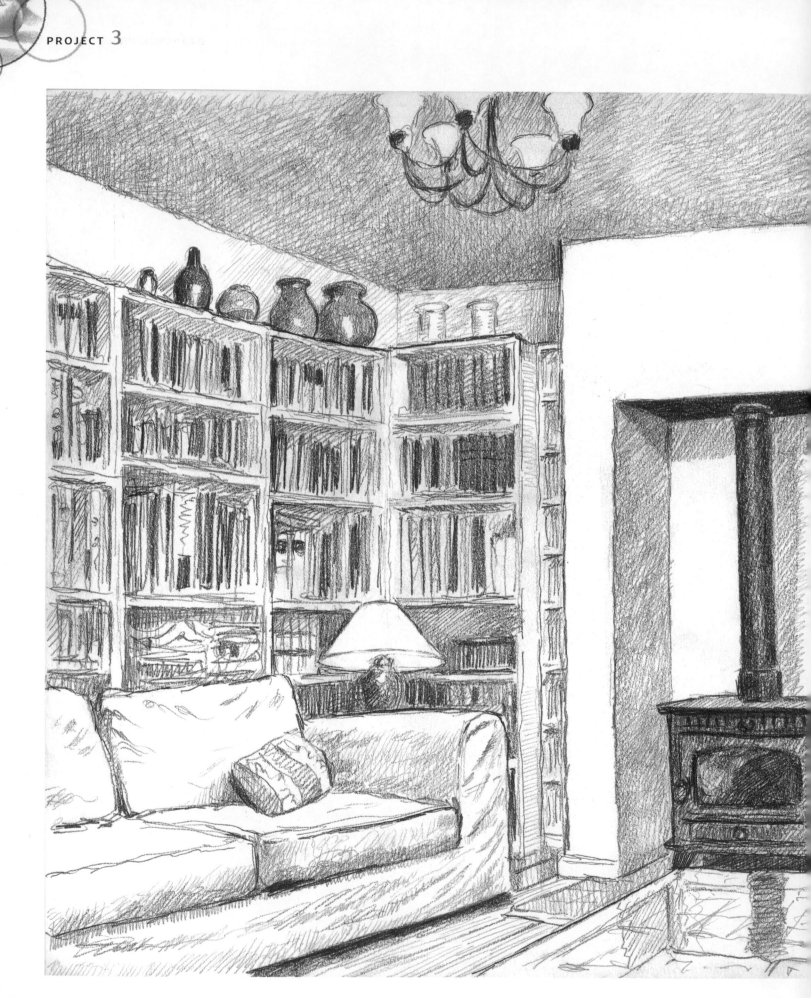

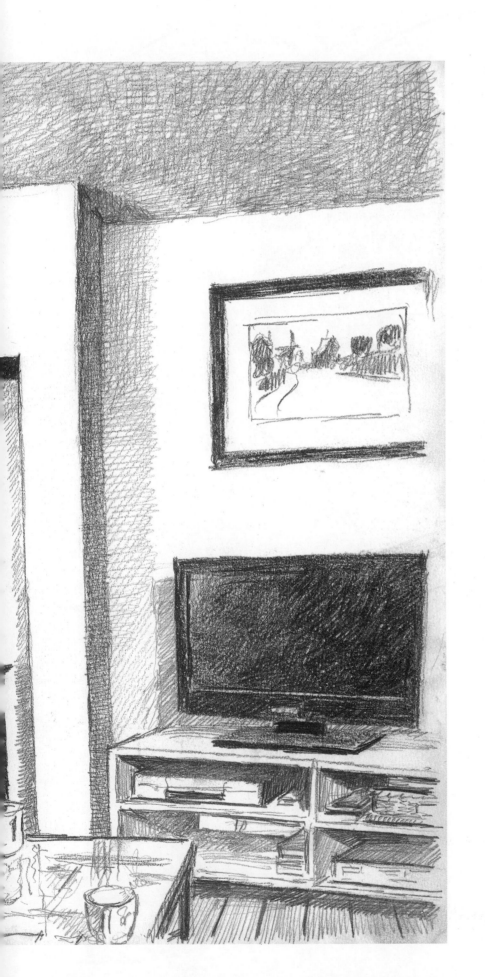

◁ Finally I had to build up the real tonal values, which are sometimes strong and dark and sometimes light and gentle. When you feel that the solidity of the scene has been achieved in your own drawing, stand back to see whether your picture holds together visually. You may have to soften or strengthen some edges, or build up the very darkest tones more intensely.

PROJECT 4: EXTERIORS – DRAWING A LOCAL SCENE

For this project it's time to take a look at subjects outside your house. To make the transition easy, my advice is to step out into your garden and then into your own street and try to draw what you see every day. To start with I suggest taking just one or two obvious bits and pieces of the scene, rather than trying to get a whole picture all at once; little details or a piece of street furniture such as a pillarbox can be quite fascinating to draw once you start to study them.

You will need to learn a little more about perspective to discover how you can give your drawing of this larger space a convincing three-dimensional quality. The principles are simple enough to understand, and it doesn't matter if your attempts at perspective don't always come off perfectly at first. There are some very successful artists who still have some slightly odd-looking perspective in their works of art.

When you come to produce your final project of a simple scene, go for something that's familiar to your everyday experience of your locality. Don't go a long way to look for some more exotic scene, because it's gaining the ability to render on paper the most ordinary sights that gives you the best practice in this work.

Drawing in your local area

If you have a garden, this can act as the first step towards exploring your locality. It doesn't matter if it's small and not an area of great beauty – the important thing is to practise drawing out of doors. If you have never tried this, starting off by tackling a landscape panorama would be very daunting and might knock your confidence. Instead, draw garden chairs or tables, pots stacked up against a wall, some trelis – small, unimportant subjects that are easy to handle, so that you can then go out of the gate with optimism that the surrounding streets will be equally manageable.

In my garden in the summer a few garden chairs were scattered about on the grass, so it was simple to just draw them in context without worrying about the whole scene.

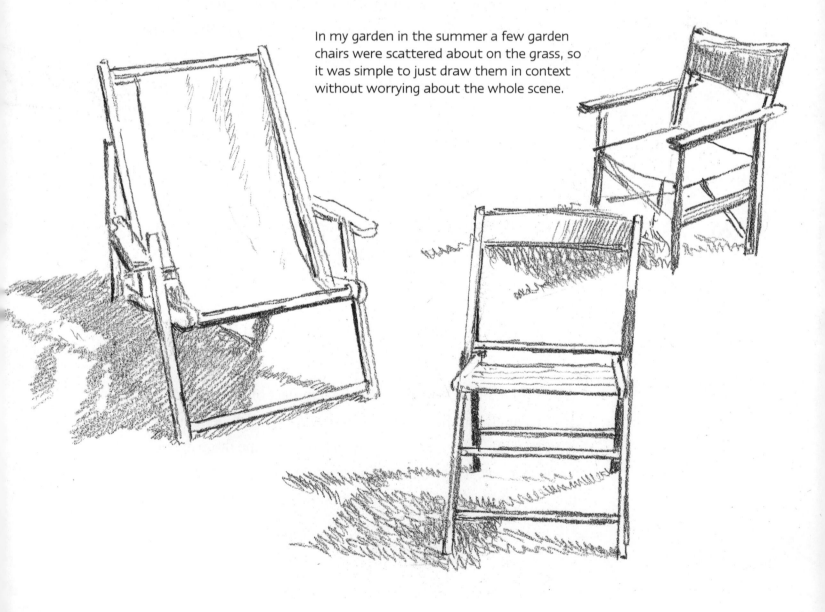

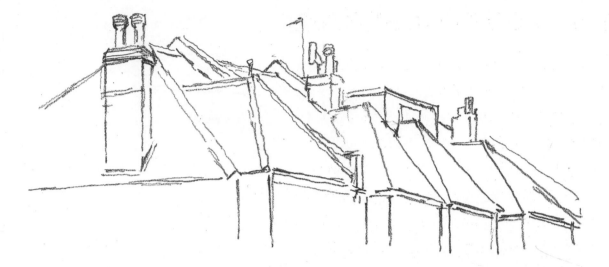

Not far from my house I drew some rooftops, a railway bridge and a group of cars parked along the road. Keeping the drawing simple, I immediately began to get a feel for the space and its general ambience – not at all neat and tidy, but rather haphazard.

On another outing I concentrated on some street
furniture, such as this letterbox, and then drew some
roadside trees.

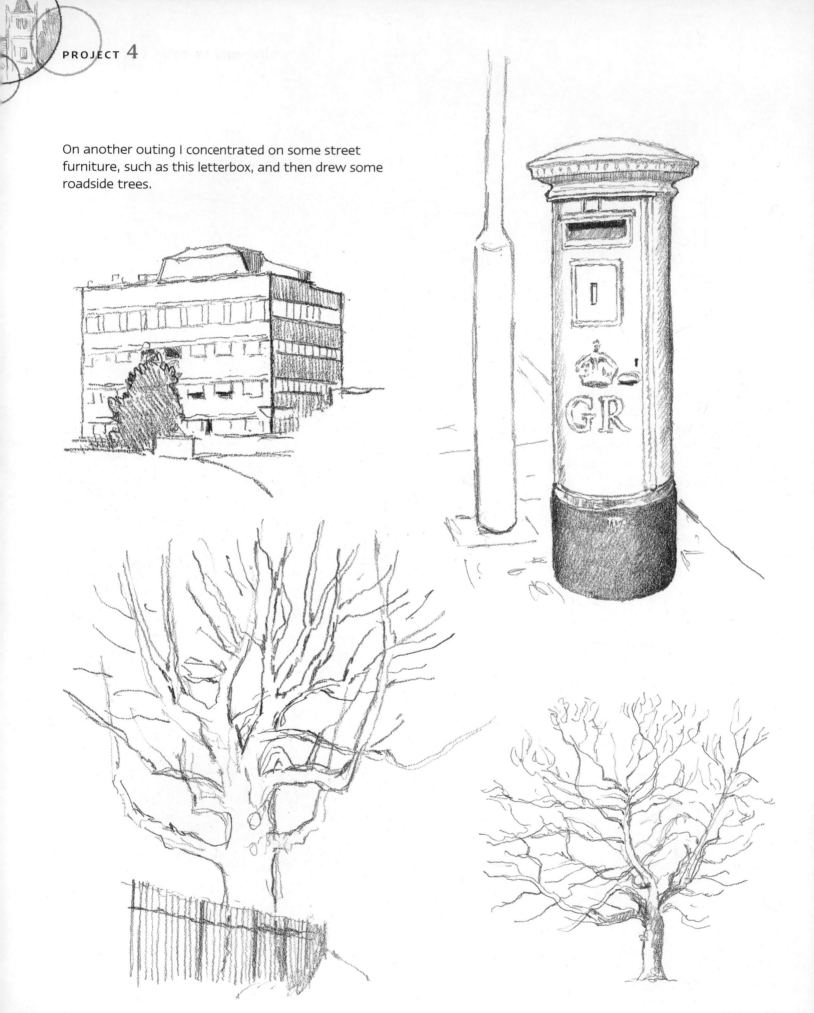

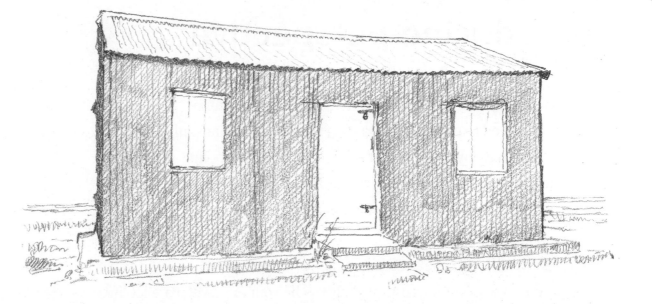

These drawings of a corrugated iron hut by the seashore and a railway bridge have a quality of emptiness, as though something were waiting to happen – for someone to enter or leave the hut, for example, or for a train to run under the bridge. In both of these drawings there is an indication of perspective giving depth, which is what we will look at next.

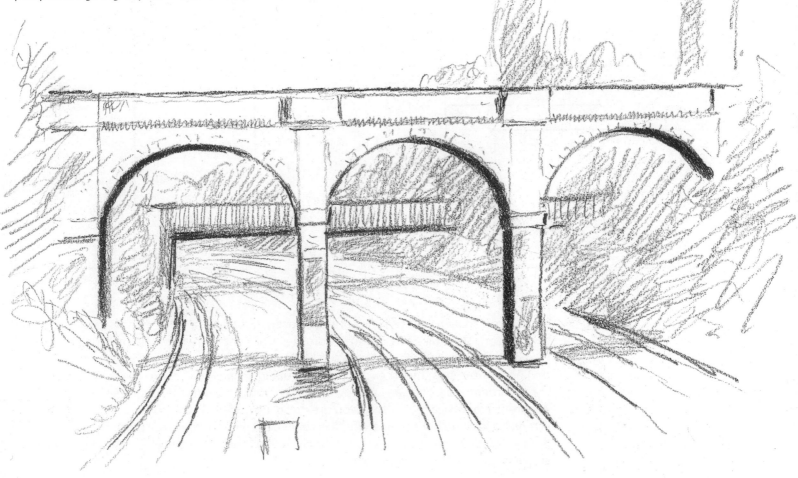

Introducing perspective

When you're drawing anything where there's a certain amount
of recession, such as in a landscape, cityscape or large interior
space, you'll need to consider the laws of perspective. Principally,
these dictate that anything further away from your viewpoint
will appear smaller than anything closer. Here I show the simple
system which you will need to employ in most of your work.

One-point perspective

The horizon line in your pictures will always be your eye level. Parallel lines
running vertically from the foreground will converge to meet at a point on
the horizon, called the vanishing point.

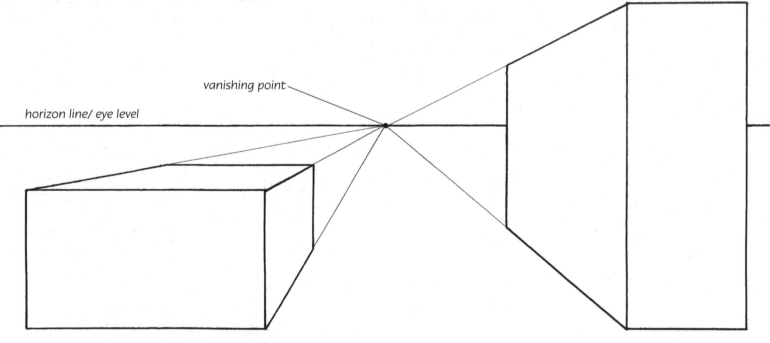

vanishing point

horizon line/ eye level

Draw a rectangle below the level of the horizon and another taller one that cuts across
the horizon. Then take fine construction lines from the corners of the rectangles so
that all join up at the central vanishing point. You can now construct with vertical
and horizontal lines the other sides of the cuboid shapes that make the drawing look
three-dimensional. You can see how in my diagram I have made the edges of the
apparent blocks heavier, so that you are not confused by all the construction lines. I also
strengthened the horizon line where it could be seen past the large block shapes.

In this type of perspective you have only vertical lines, horizontal lines, and those lines
converging on the vanishing point.

Two-point perspective

When you use two-point perspective the same rules apply, except that this time there are two vanishing points, which will be at opposite ends of the horizon line. This means that your first vertical lines will be in more or less the centre of your drawing.

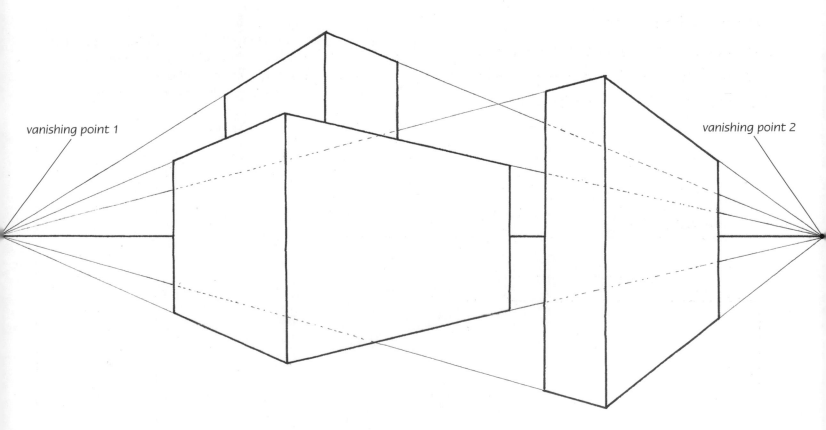

vanishing point 1

vanishing point 2

Here two apparent blocks are set alongside each other. This time the construction lines are drawn from these largest verticals to both of the vanishing points either side.

The next thing to do is to draw more verticals limiting the size of your blocks as you wish. They will appear on either side of the original vertical, parallel with it. Once again I have strengthened the outlines of the blocks and the horizon line where it is visible behind the blocks in order that the eye is not too confused with all the construction lines.

In this type of perspective there are only verticals and lines joining the vanishing points, so it is not too complicated. But it does make you see an apparently three-dimensional space in which there are a couple of building blocks.

Perspective in a landscape

These simple diagrams give you some idea how important perspective can be in a landscape that has many manmade features in it. It's not always so obvious in nature, but the same rules apply if you wish to show the depth of the space in the picture.

The first diagram is of a railway track with trains approaching and receding from our view. Notice the simple single vanishing point where the railway tracks disappear to a point in the middle of the composition, giving drama to the railway trains. All the surrounding buildings and lamp posts follow the same pattern of converging lines.

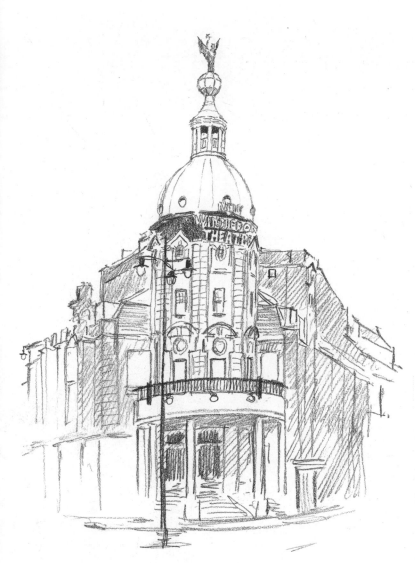

The next scene of a large corner building is in two-point perspective, in which the lines of the tops and bases of the buildings converge from the centre towards the outside edges. As always the horizon line or eye level is important, although it is more difficult to find in a large built environment like this.

The last example is in fact of two-point perspective, but one of the converging sets of lines is much clearer than the other. This is because the main façades of the buildings are to one side and the hedge and edge of the road emphasizes this direction. However, you can see that the side of the building recedes towards the opposite side although it is slightly masked by the tree.

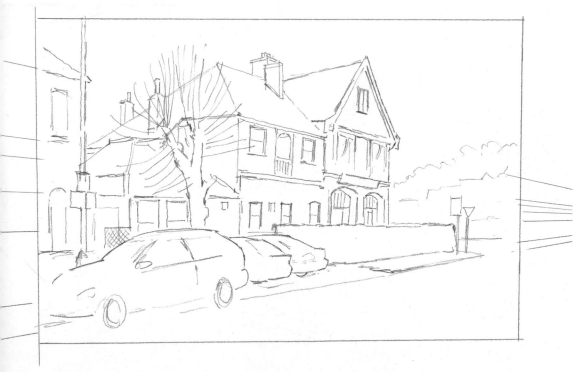

51

PROJECT 4

Drawing a local scene

As I live in deepest suburbia, this seemed to be the right place to start finding ideas for a local scene since it is the type of area many of us inhabit. Of course, if you live out in the country or by the seaside, you can take advantage of your situation to bring in the greater glories of nature.

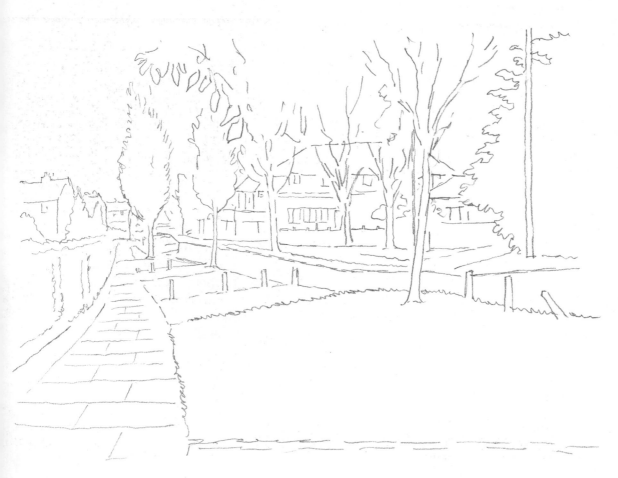

First, as always, I made a quick sketch to get the area that I was going to draw clear in my own mind. There was a patch of grass right in front of me with a road curving away and plenty of trees around.

Then with more care, attempting to get the perspective accurate, I drew a careful outline of all the parts of the scene, so I could differentiate between trees, bushes, pavement, grass and houses.

▷ I put in the main tone all over the picture, not yet differentiating between the darkest and lighter tones. This gave me a good idea as to where the greatest emphasis in the spatial qualities of the scene could be made.

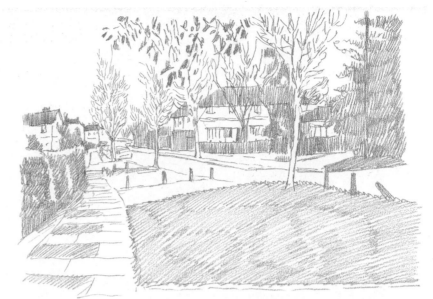

▽ Next I built up the darkest areas with more and more tone. These were mostly parts of the houses and the evergreen trees. I was lucky to have a very dark yew tree on the right-hand side of the picture which acted as a framing device and I emphasized the overhanging leaves at the top of the picture a bit more to also help frame the scene. This is the sort of artistic licence that can greatly improve a drawing.

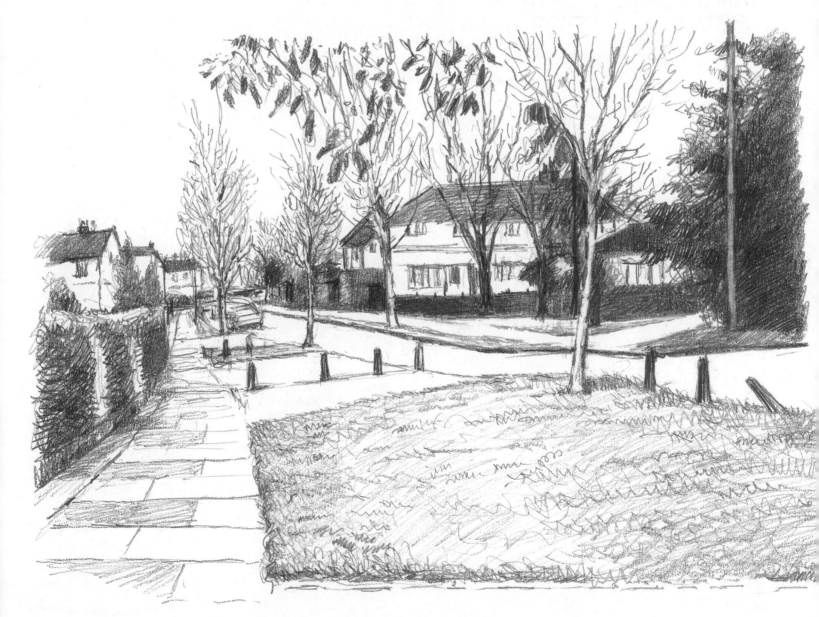

PROJECT 5: LANDSCAPE COMPOSITION

This section is all about getting to grips with the composition of a landscape. Although it might seem that you don't really need to compose a landscape as it's already there in reality, you do indeed choose your point of view, eye level and the expanse of the scene. Dividing the view into background, middle ground and foreground will help you to deal with the immensity of open areas of countryside.

Of course there are many different types of landscape, from great mountain ranges to woodlands and fens. However, most of us don't live in such wild places and the best time for tackling landscape drawings tends to be when you go on holiday to somewhere totally unlike your normal environment. Holidays are a brilliant time to get really stuck into some serious work with your pencil and sketch pad.

There are many ways of approaching a landscape, and your own particular view is part of the interest that your drawing will create. A very high eye level or a dramatization of one part of the scene are both valid approaches for an interesting composition. Expanses of calm or turbulent water, large trees and stunning rock formations all bring extra power to your drawing, so make the most of any unusual landscape you come across – but don't feel deterred by more mundane terrain, as the way you handle it can equally catch the viewer's eye.

The structure of landscape

Before you start to draw a larger and more complicated landscape from life, it's advisable to consider how it can be approached schematically. The first point to realize is that in any large open landscape, there's an area of sky with the background immediately below it, then the middle ground and finally the foreground. The horizon line is the edge of the background against the sky.

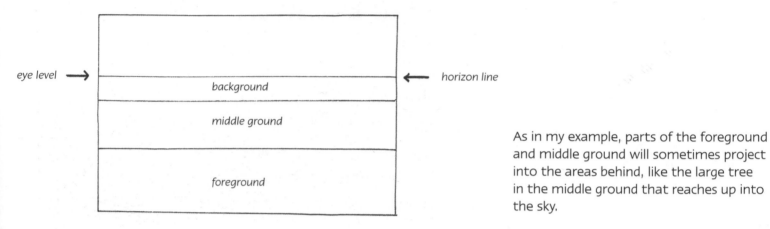

eye level → | background | ← horizon line

middle ground

foreground

As in my example, parts of the foreground and middle ground will sometimes project into the areas behind, like the large tree in the middle ground that reaches up into the sky.

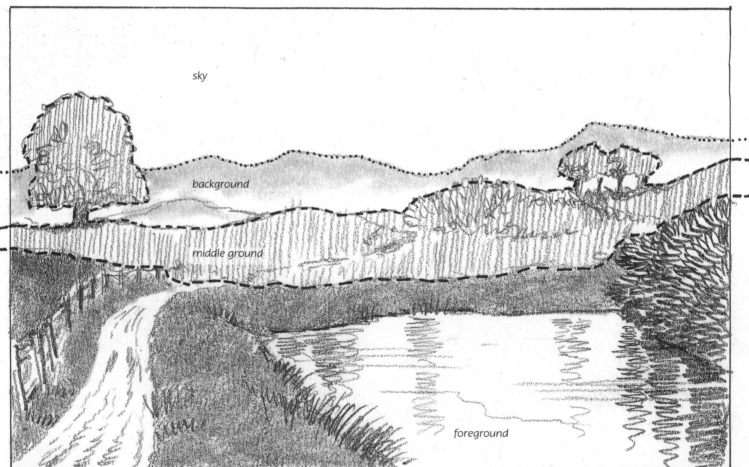

sky

background

middle ground

foreground

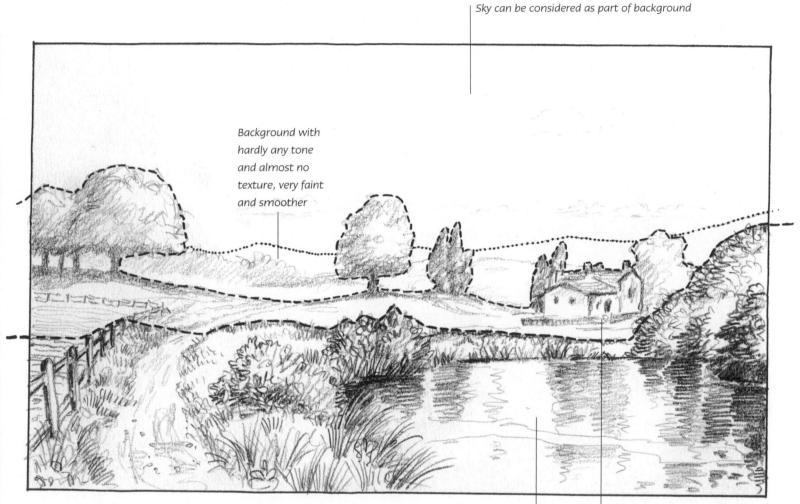

Sky can be considered as part of background

Background with hardly any tone and almost no texture, very faint and smoother

Middle ground with tone and texture but softer and less intense than the foreground

Foreground with intense tone and contrast and strong textures

In this next version of a landscape we're also aware of the fact that the background area is very faint and without detail or much texture – in fact in places it's almost as light as the sky. The middle ground has a little more definition and texture, but still not much detail. The foreground has the greatest definition and the most texture and intensity of detail. This is a result of what is known as aerial perspective, where atmospheric haze makes landscape features at a greater distance appear much less defined than those in the foreground.

Types of landscape

The never-ending interest of drawing landscapes is that there's such a variety of forms, textures and compositions encompassed by the genre. While we all have a particular type of landscape that calls to us the most, it's always possible to find a scene that sparks off a drawing. Over the next pages we'll look at various landscape compositions, one after a master artist and the others my own.

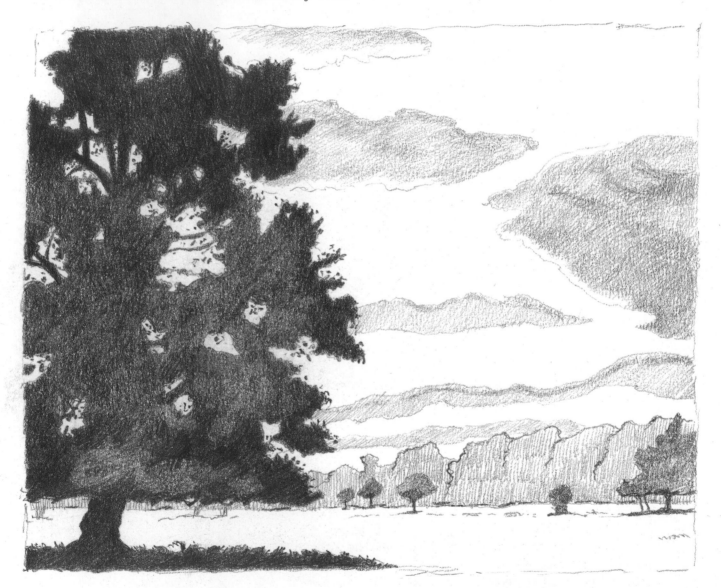

Our first example is of a large tree that dominates the foreground and in fact the whole picture. The sun is rising behind it so bright patches of light can be seen through its very dark silhouette. The fact that this tree stretches from the top to the bottom of the picture and takes up almost half of the composition means that the rest of the landscape is subordinate to it. Indeed, the picture appears to be mostly background – though the expanse of the field behind the tree is middle ground, it's not very obvious. The row of trees in the background is not much more detailed than the sky, and here the clouds play a big part in the composition. The complexity of this composition is subtle and depends on your ability to draw the clouds interestingly enough to contrast with the dominant tree.

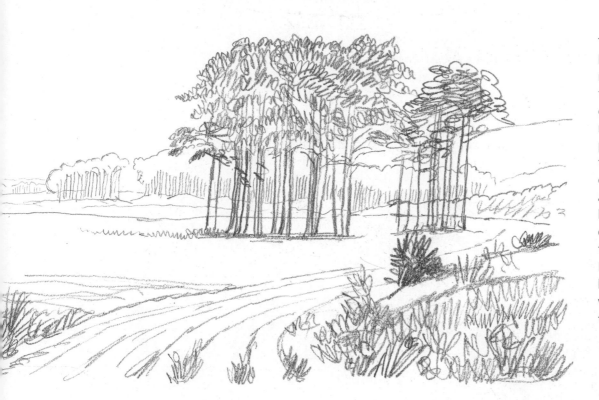

The next picture is of a landscape in which the main feature is again trees, but this time a group of them in the middle ground. A curving path extends from the forefront of the composition and swings around behind the trees, helping to pull the viewer's eye into the picture towards the main feature. Behind that is a row of low hills covered in vegetation with a bank of bushes in the near foreground.

The third scene is of a mountainous landscape with rows of rocky peaks in the background, similar terrain in the middle ground and scrub-covered lumps of rock in the foreground. The great difficulty in a scene like this is to show the difference in distance between the nearest outcrops and the distant mountains. If you're lucky there'll be some light mist between the further ranges and the middle ground outcrops, as in this picture; if not, rendering the texture and detail well-defined in the foreground and lessening towards the background is the best way. Notice how in this example the view has been selected so the nearest mountains are shown to the sides of the picture, and the furthest mountains are most prominent in the centre of the composition.

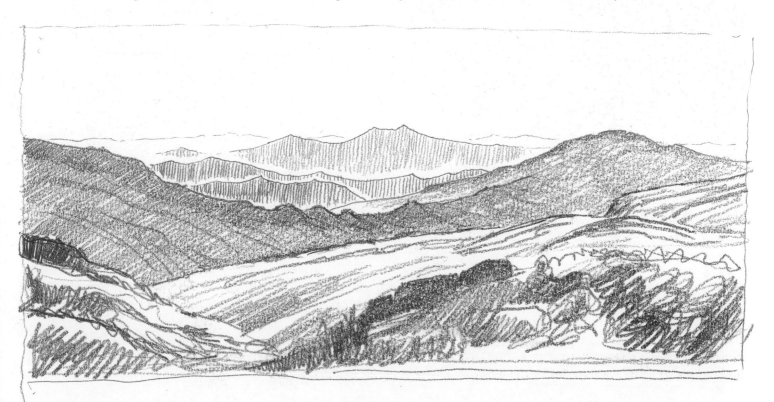

Here's a composition rather like the first example on page 58, in which a very large tree in the foreground tends to dominate the scene. However, unlike the first picture, the lines of the ploughed landscape pull the eye into the scene and lead it into the background hills and woods. The structure of the main tree is very evident here and becomes the most interesting part of the drawing.

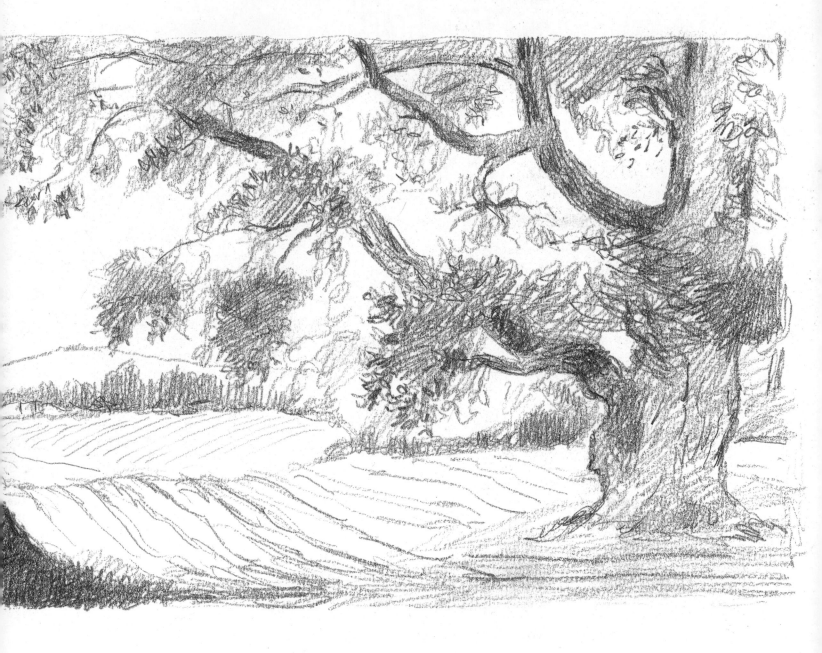

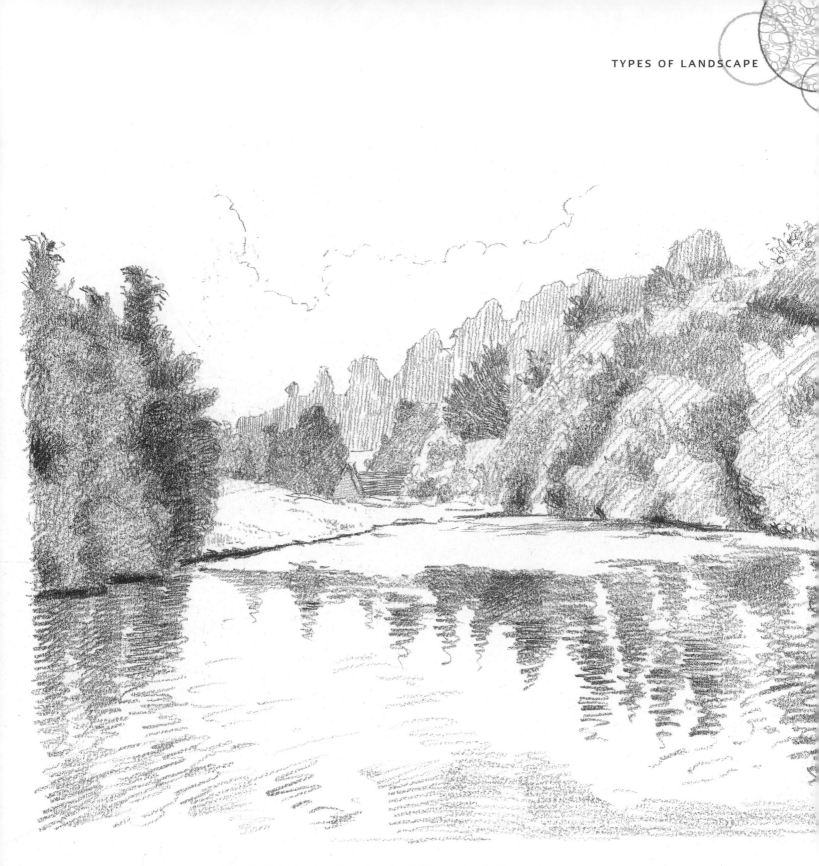

The next scene is primarily about the water in the foreground and how it reflects the rest of the scenery in the surface. The middle ground is mostly trees with a gap opening up the background to one side. As the lake takes up half of the whole composition it's quite important in the drawing and the reflections need to look convincing.

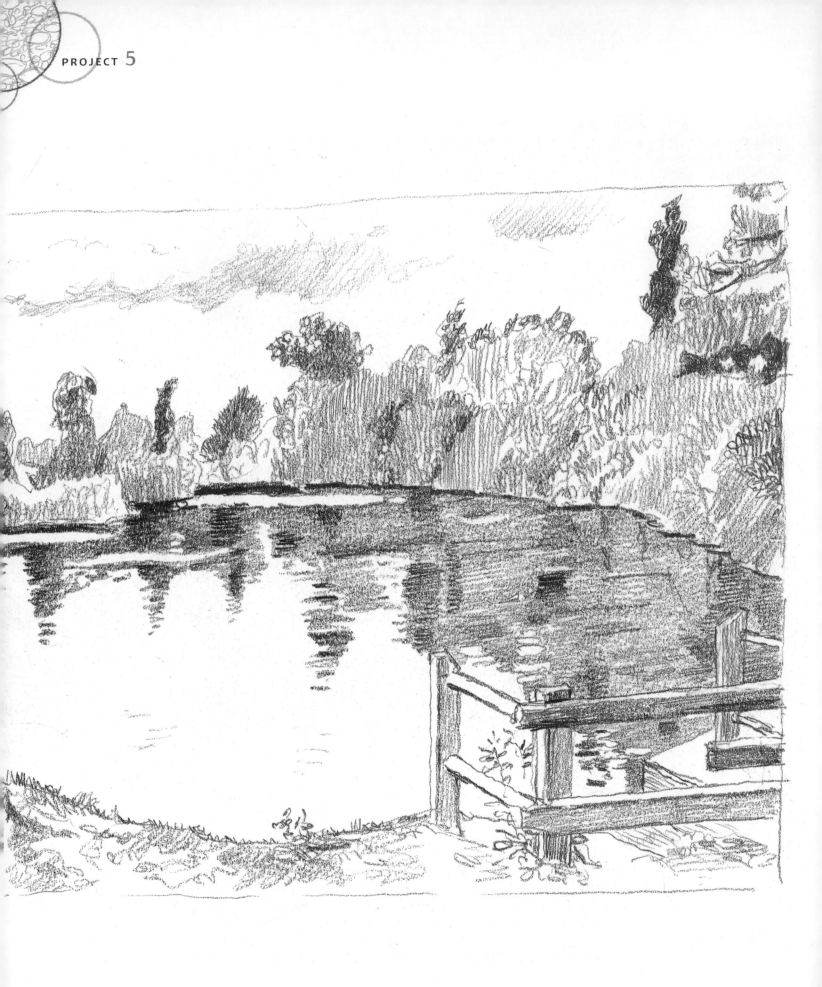

The scene on the left is another one in which water is the dominant feature, but this time it's given added depth by the device of including some ground and a small piece of fencing in the foreground. The main middle ground and background curve away on the other side of the lake, disappearing in a mass of reeds and vegetation over on the far left. Once again the reflection in the water is the key to this composition.

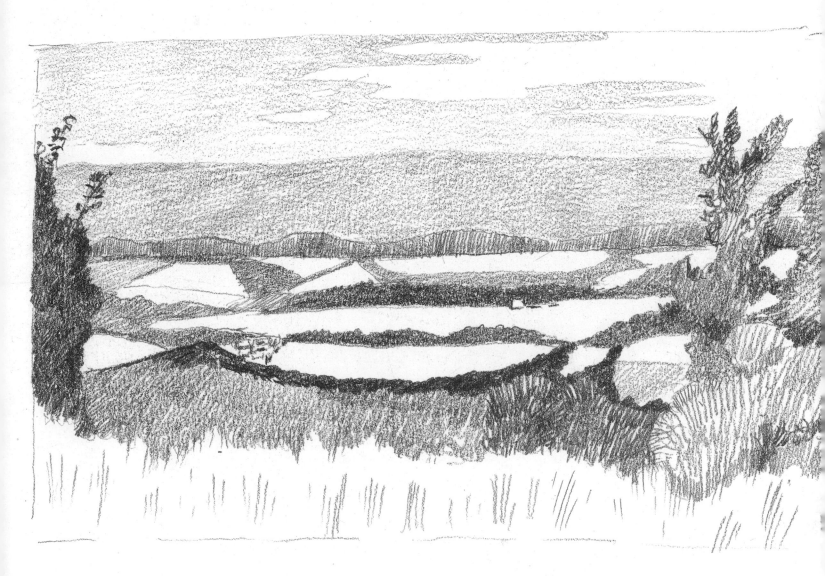

The following scene is less dramatic but, treated carefully, this kind of wide, open landscape can give a very good feel of depth in the picture. The foreground is composed of the tufts of grass and bushes on the edge of the hill that I was drawing from, which gives a good view over the fairly flat countryside stretching off into the distance. Behind that is a large area of dark cloud, above which is a lighter, more streaky sky. The texture of the bushes and grass in the foreground is important to give the right effect of space.

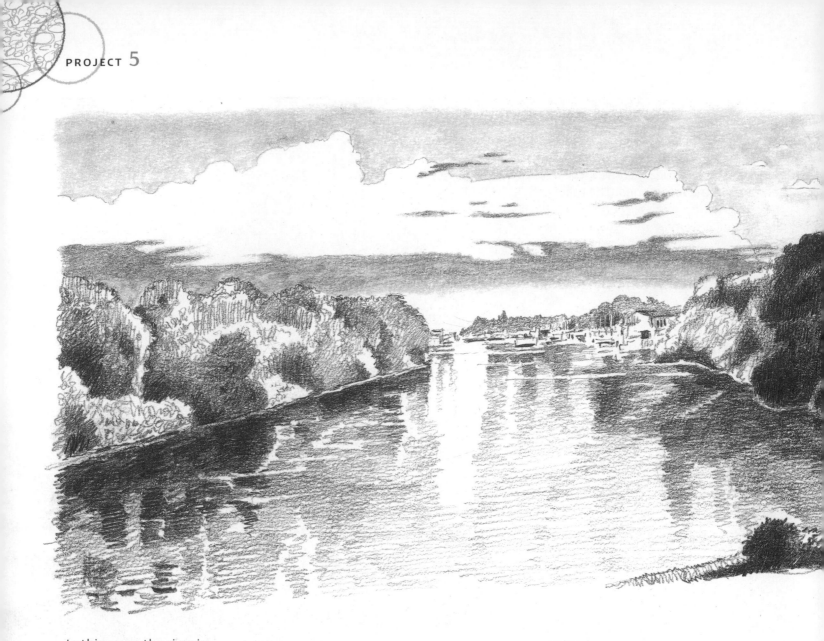

In this scene the river is pulling the eye towards the distant scenery, but the dramatic cloudy sky above seems to stretch our attention sideways to consider the breadth of the space. This sky with its reflection in the river surface is quite effective in opening up the space in the scene. The arrows in the diagram on the right show the direction the eye takes when reading the image.

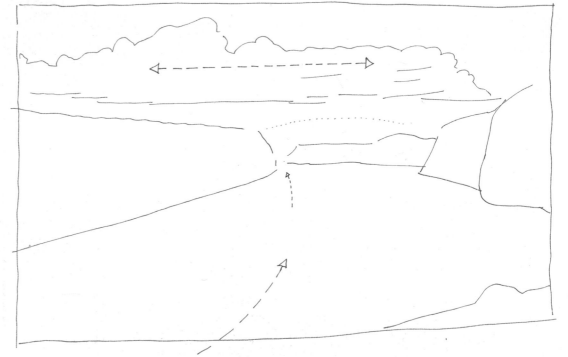

The next scene, of the dramatic coast in Dorset, England, is more complex. The centre of the composition is the circular inlet of the sea in the rocky cliff face. All the lower parts of the picture seem to indicate the direction towards this centre. The cliffs immediately above the pool also move the eye down to the water. The sky, the slanting line of the cliff top with its row of trees and the distant downland all move the attention towards the centre line of the cliff face, which dips down towards the edge of the pool.

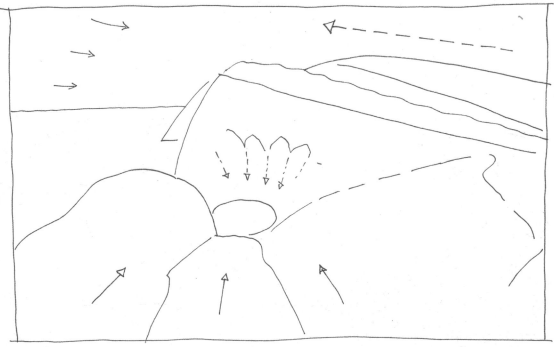

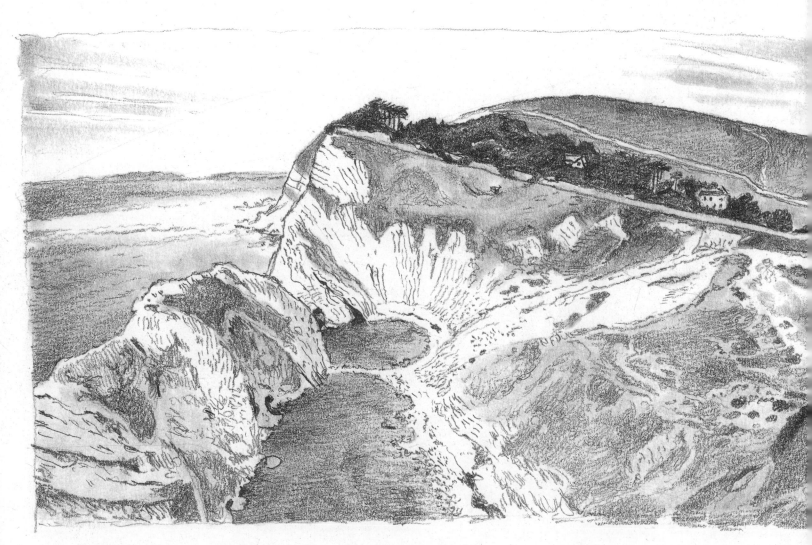

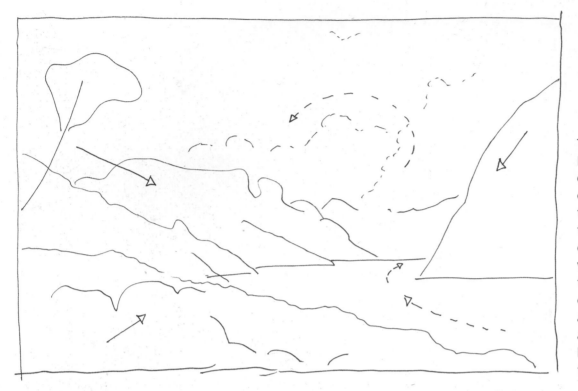

This drawing of the English Lake District has a similar effect to the coastal scene on the previous page in that the rocky edges of the lake all seem to draw our attention towards the water. The water appears to swing around the edge of the rocks, while the activity of the clouds swirls around to bring the eye back to the centre of the scene.

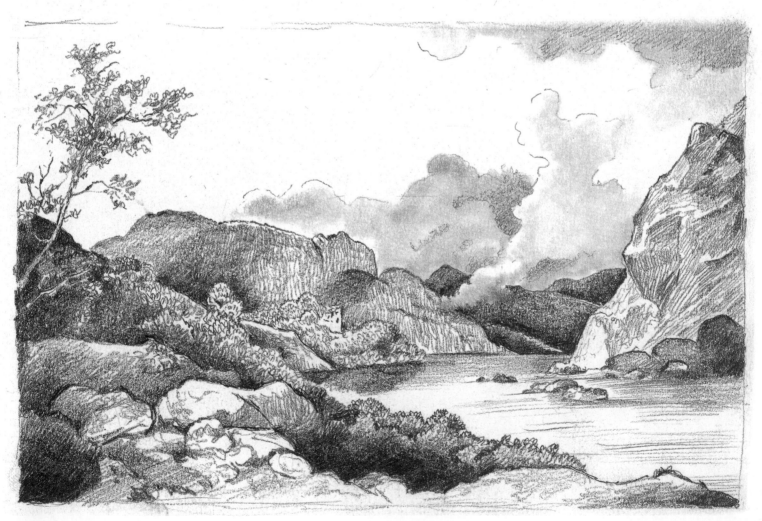

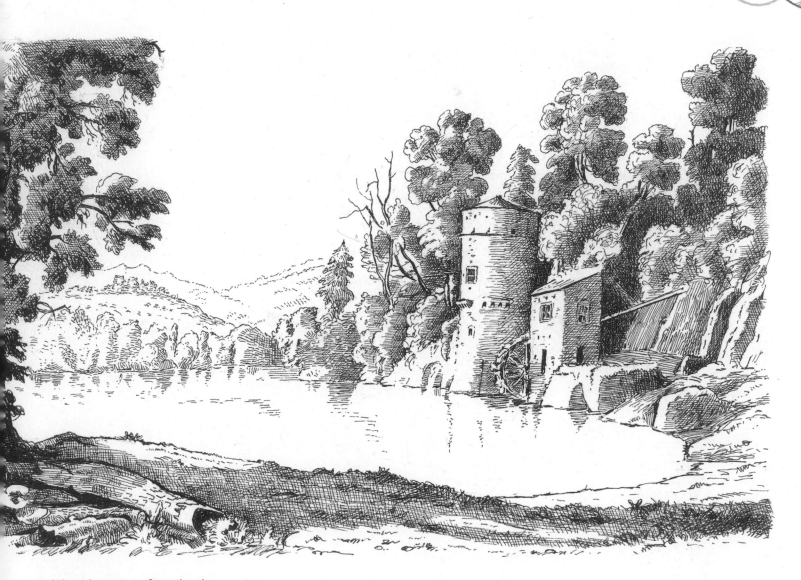

A lakeside scene after Claude Lorrain (1602–82) is slightly more complex, as you would expect from this master of landscape. The big tree on the left hems in our vision, while the foreground pulls our attention towards the area of the water. The outline of the distant landscape and the large trees sweeping down to the river on the right also concentrate the eye on the water. However, the key element is the strong vertical tower built on the riverbank which holds our attention for contemplation. This is the real centre of the piece and everything else tends to pull our attention towards it or across it.

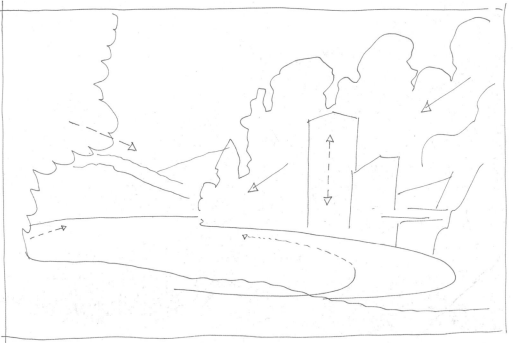

PROJECT 5

Landscape composition

When I decided to put together this final piece of landscape drawing I went to Hampton Court on the River Thames, close to where I used to live when I was a boy. Although there are plenty of houses in the vicinity, they are all well hidden by trees and the areas of footpath along the river. Also close by was a pleasant park that I used to play in when I was young, which was quite nicely wooded and had a small lake in it.

▷ First I walked around the park and the river to get ideas for my drawing. In the park I sketched very quickly this possible scene of the lake, which seemed nice and open.

▽▷ Then I walked along the riverbank, making these three rough sketches of places I might choose to draw. As well as the sketches, I took several photographs of all the possible places that seemed attractive to me.

▽ Looking at my sketches, I tried to decide which scene I was going to draw up more carefully. I returned to the park and began this view of the lake, with the rippling water and the willow trees around it.

As you can see I produced a fairly complete drawing, but somehow I was not quite satisfied with the result. You will find this often happens, but it doesn't necessarily mean that there is anything wrong with your drawing – artists are often the sternest critics of their work and they cannot be truly objective about it until much later on.

▲ I was keen to try something else, so I went back to the riverbank and walked until I reached a spot that I had both sketched and photographed. I made another sketch, taking a bit more time over it than before.

▶ Satisfied that this was the place I wanted to draw, I then sat down and began to work more carefully on simple outline drawing of the scene, making sure that all the trees were correctly aligned, and that the edges of the river were clearly marked. It had been raining, so there were many large puddles along the river path.

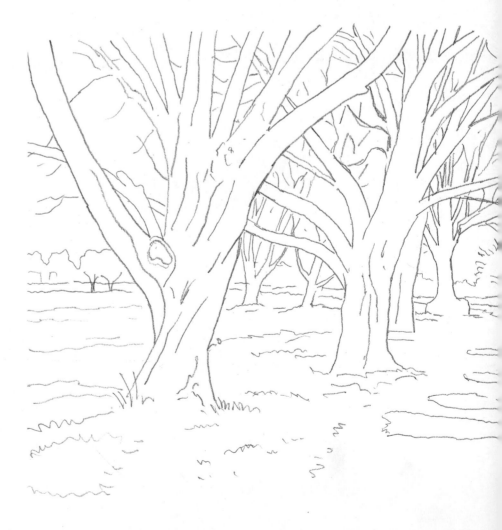

▲ Then I began to put in the tones
that were evident, as well as textures,
especially of the tree bark and the
longer grass. I tried to keep this as even
in tone as I could so that I would be able
to see where the heavier and darker
marks were going to be put later.

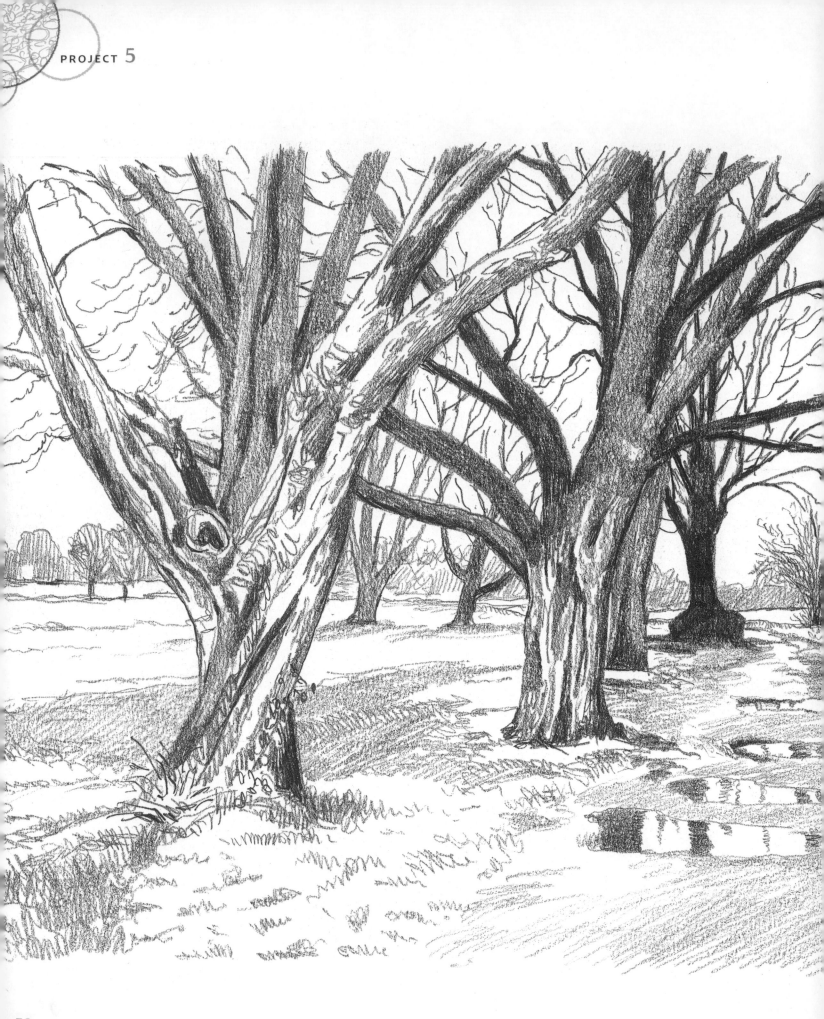

▽ Finally I worked up the drawing so that all the very dark tones and heavier textures would play their part in the balance of the composition. At this point the reflections in the puddles had to be carefully shown, as well as the ripples on the river as it flowed past. Because by this time the sun was in the west, a lot of the trees were almost silhouettes, which helped to define the edge of the river and the trees in the distance. This seemed to me a more interesting drawing than the previous one (page 69) because there is more drama in the arrangement of the bare trees.

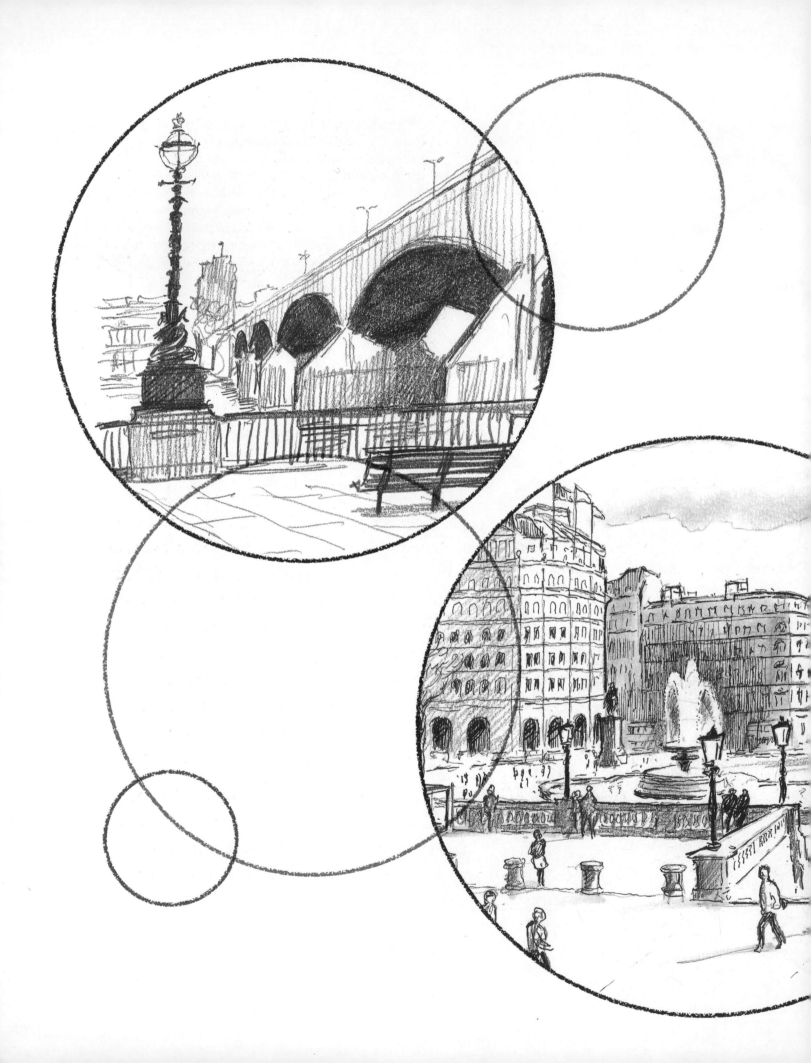

PROJECT 6: **CITY PANORAMA**

The problem you'll find in tackling urban scenes is that there's so much competing for your attention it can be difficult to make a sensible choice of subject. However, the same rules apply as in a rural landscape – select how much you are going to draw from your own viewpoint, and don't be confused by a lot of detail.

What you'll discover in the urban environment is that there are lots of incidental bits of architecture that seem to demand that you put them all in. However, this is where you have to decide exactly how much of this detail will be drawn precisely and how much will be reduced to very simple marks that just suggest the detail. Features such as windows, doors and chimneys are the obvious elements that come into this category. Most of what you see is recorded in your mind only as a general impression, and this is probably the best way to show it. The details that you do have to be precise about are those that are in the foreground or are points of focus.

Remember that you don't have to put every building and piece of street furniture in, especially if it might produce an awkward area of design in the whole picture. This is where you can use artistic licence to create the best composition rather than simply making a record of the scene.

Street scenes

Looking at the urban scene presents a different problem to the rural landscape because your view will often be cluttered with multiple signage, cars and so forth. For this reason, if you live in a quiet residential area it's a good idea to progress gradually from there to the centre of the town.

So our first compositions here are streets of residential housing with roadside trees, cars and minimum signage. Even so your spatial area will be rather constrained by the narrowness of the streets and the closely built houses.

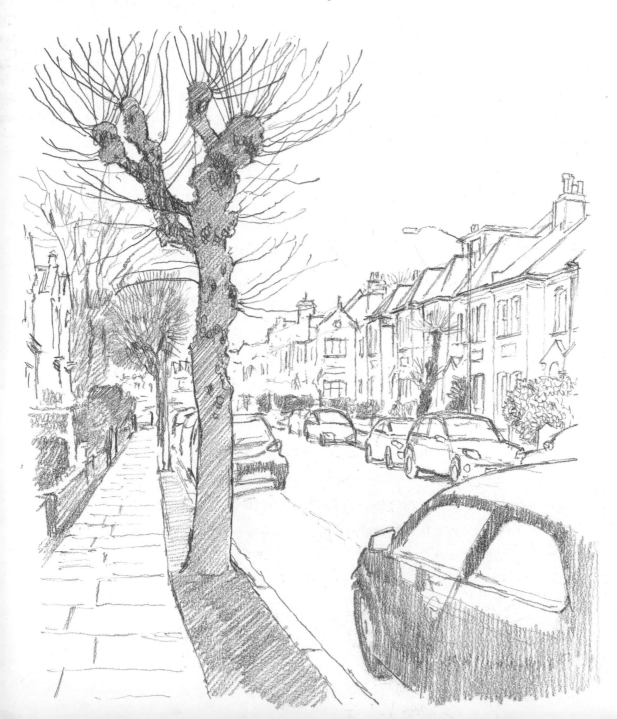

This drawing is a view down a road with the houses on the opposite side jumbled together and the pollarded tree at the side of the road acting like a frame on the left of the picture. The cars alongside the kerb are significantly cutting off your view of the road, which is the largest space in the scene. You immediately see how this lacks the spacious qualities of the more open landscape of the countryside.

The next picture is of a town where the road divides, giving a concentrated view of the near side of the road and a more open view of the far side. The lamp post, road sign and parked car give you an easy introduction to the street paraphernalia possible in urban scenes.

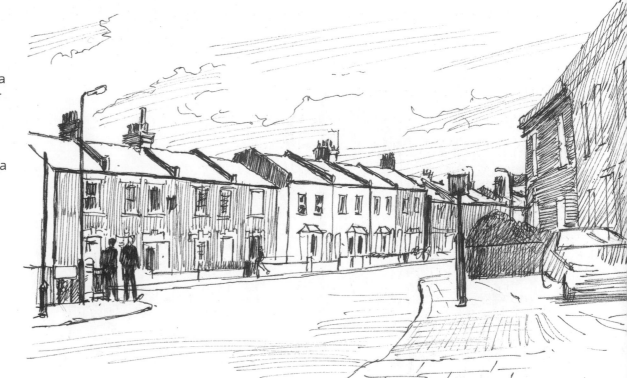

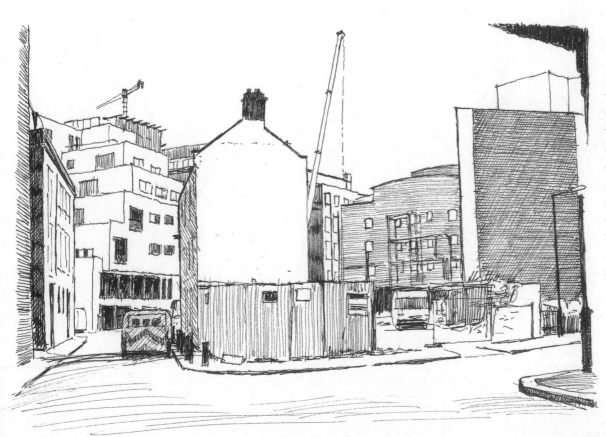

Here some building works are taking place in a city location where sheets of corrugated iron fence off the site from the pavement. The crane and scaffolding in the centre of the scene are framed by the large new buildings on either side.

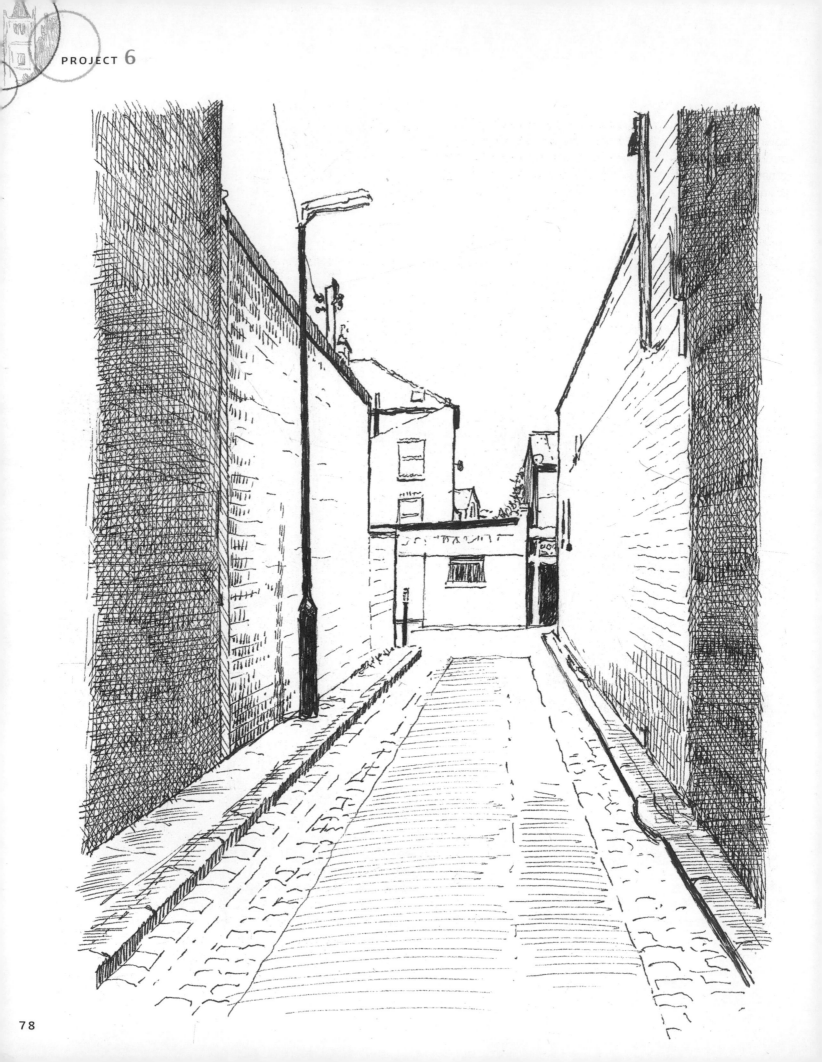

Now a couple of awkward spaces in the centre of a town. The picture on the left shows a narrow alleyway between rows of shops, giving access to areas behind the commercial frontage. It is rather like a large slot in the buildings, showing a little sky and blank brick surfaces.

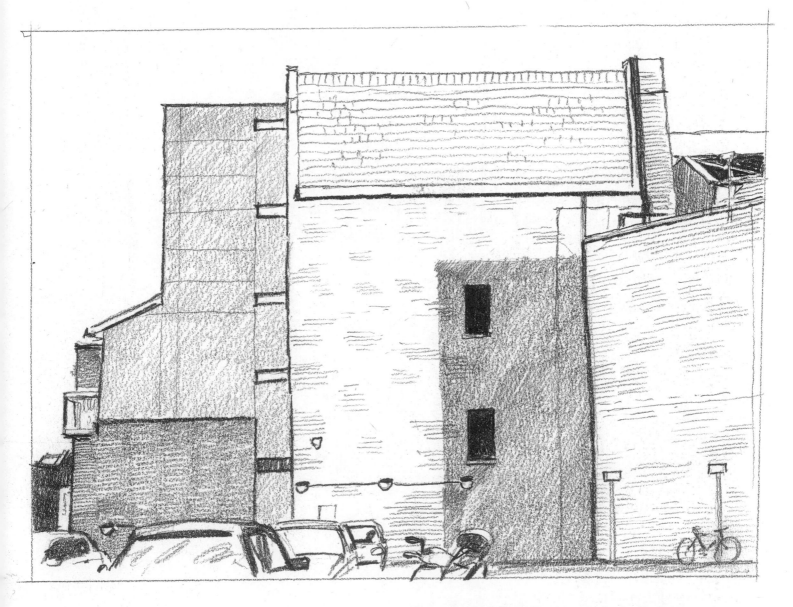

The second of these two scenes is the back of some large buildings, where a car park is in temporary use. Soon these spaces will be filled by new buildings, but until then we have a view of these large blank surfaces which indicate that these are not the main fronts of the buildings concerned. This is really an exercise in drawing large areas of texture and cast shadows.

A trip to the city

I decided to go on a journey to get some examples of urban landscapes that had some direct significance for me, so I took the train to London's Trafalgar Square. This is one of the city's main focal points, and I thought that I would be able to find plenty of scenes that gave a good idea of the problems to be solved when drawing in a busy urban environment.

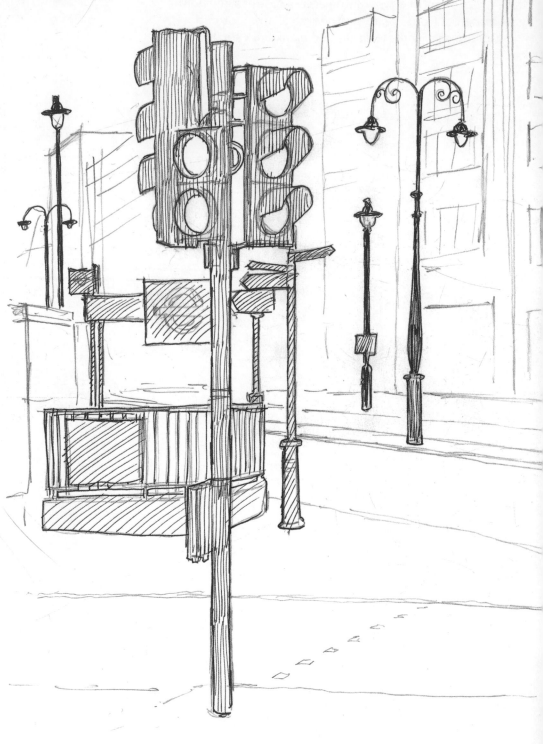

Immediately on emerging from the station I was confronted by two views of the end of a large thoroughfare called the Strand. Here is the mass of lamp posts, traffic lights, rubbish bins, bus stops and railings that make up the everyday look of a London street. Notice how the traffic lights and lamp posts are all clustered together from the position in which I was viewing the scene. I have purposely left the buildings only outlined in order to point out how much of the scene can be taken up with street furniture.

In the second picture there's also the addition of free-standing notices placed outside shop fronts to attract customers, and one of the old telephone boxes that are still seen in many London streets.

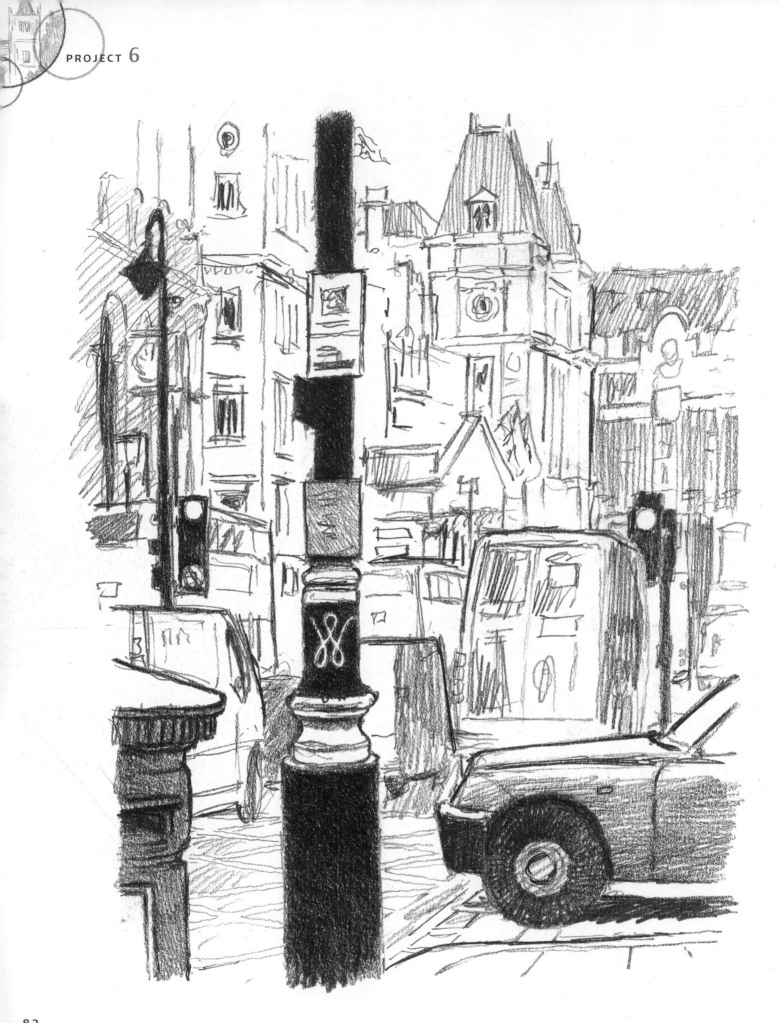

In the picture on the left you can see how the traffic jams in large towns always give a crowded look to the streets and with the lamps and other paraphernalia the whole picture can look very busy. This isn't a bad thing, because this may well be what you want to portray as typical city life.

However, you can find big spaces as well, especially if, as in London, there's a river running through the town. This view is on the south bank of the River Thames looking up at Waterloo Bridge. There are walkways along the side of the river which allow you to step back and see some very nice spaces contrasting with the solid architecture of the massive spans. The deep shadows under the bridge bring a certain drama to the scene.

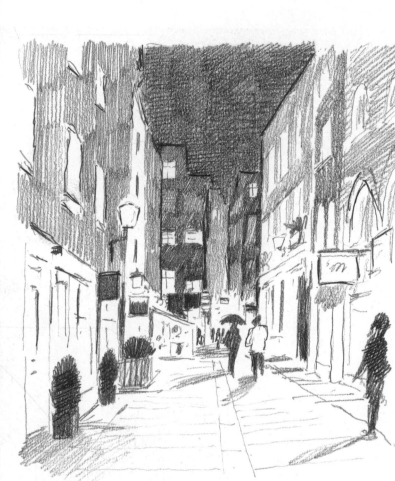

This drawing of a pedestrian walkway between shops and restaurants gives a good idea of the bright streets at night in a town. Figures walking along the street tend to look like silhouettes.

Here's a similar effect by daylight, seen from the top of the steps up to the National Gallery in Trafalgar Square. A large ornamental lamp stands in the centre of the picture, and around it can be seen a street of large classical buildings stretching off into the distance. The people dotted about help to define the space between the viewer and the buildings.

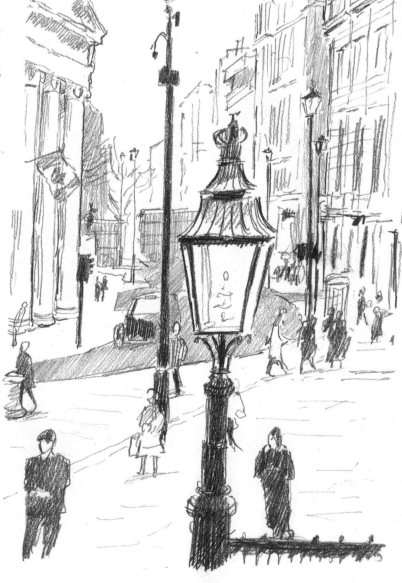

And now the view is from the lower part of Trafalgar Square, where once again the street furniture becomes a way of defining the space between the viewer and the figures and traffic. It's quite difficult to draw people as they pass by in the street, so the best way is to take photographs that incorporate the pedestrians so that you can place them in the scene afterwards. I have used ink again here because I find it is sympathetic to drawing the details of the buildings.

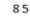

PROJECT 6
City panorama

To make a sufficiently dramatic scene to show the most effective method of drawing in the city, I chose as large a panorama as I could of Trafalgar Square, without trying to get everything in. I placed myself in the middle of the steps of the National Gallery and looked straight across the square towards Whitehall with Nelson's Column right in the middle of the scene, but without being able to see the top, where Nelson's statue stands. This gave me a focal point for the scene without including a large expanse of sky. After all, I wanted to portray the city buildings rather than just the central column.

▽ To start with I sketched in the main areas of the blocks of architecture, indicating the open space of the square where people were wandering about. I did this in pencil so that if any of the spaces were wrong I could erase them.

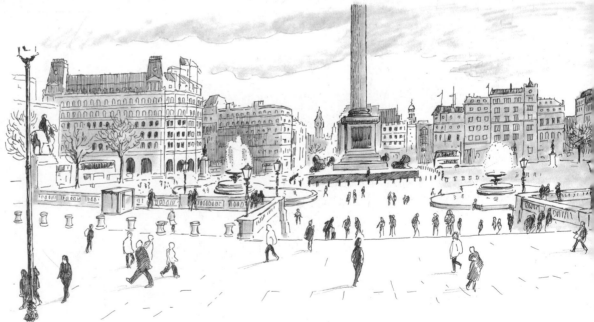

▲ Next, still using pencil, I drew up the whole square in some detail, although the large numbers of windows visible were put in as simply as possible. At this stage I could still alter anything that didn't work, and if I decided I didn't like the position of a tree or lamp post, or even a rooftop, I could get rid of them. My aim was to maintain the overall spacious quality of the scene rather than worry about every detail.

▲ Having got the whole scene drawn in I could now put in more people, and add some tone as well. I decided to mainly use ink and so the first thing was to draw the whole picture all over again with a pen. This may seem a bit tiresome, but it can often lead to a better picture. I also started to mark in the tones of the main buildings with a very soft all-over tone, which helped to show up the white splash of the fountains in the square. I did this with pencil to keep it soft at first, then I went over all the areas that I wanted to be more definite with inked-in areas of tone, which looks a lot darker than the pencil. At this stage I put in a lot of people crossing the square and looking at the fountains.

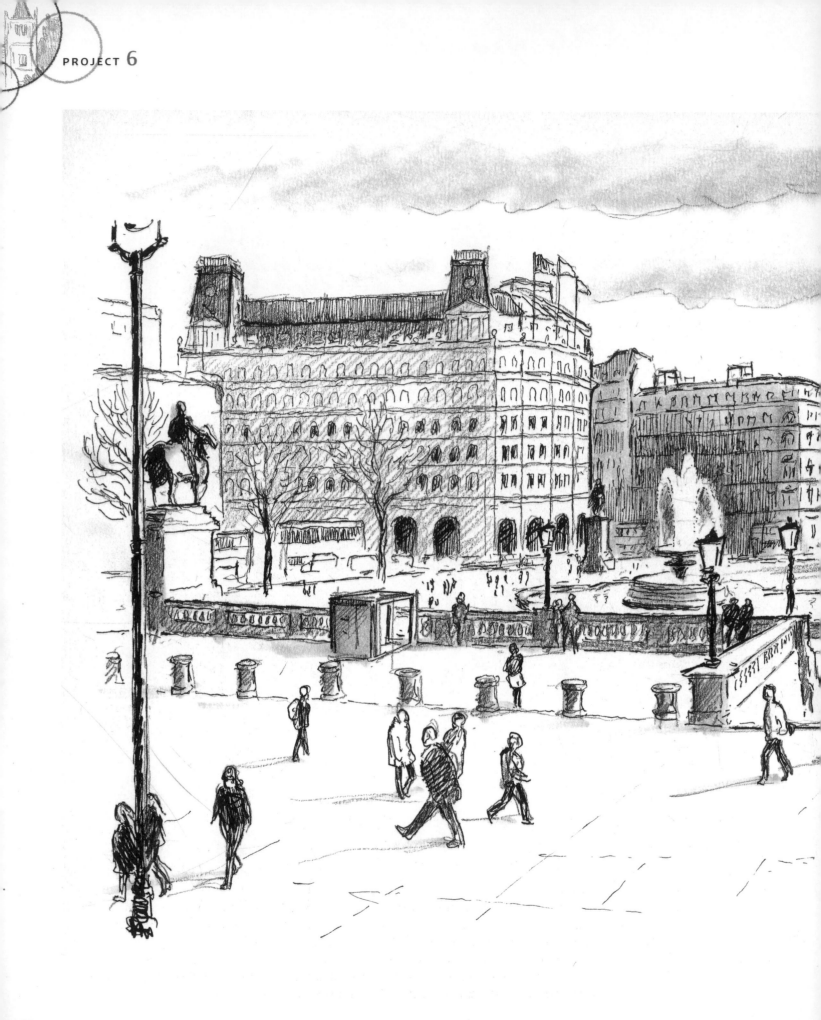

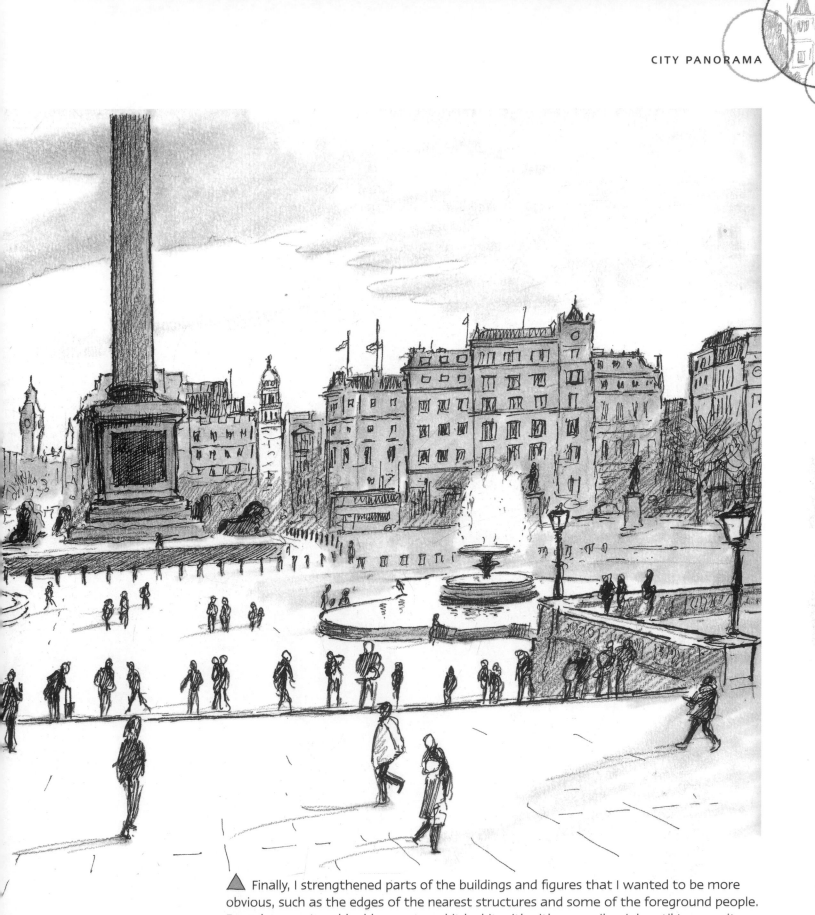

Finally, I strengthened parts of the buildings and figures that I wanted to be more obvious, such as the edges of the nearest structures and some of the foreground people. From here on I could add more tone bit by bit with either pencil or ink until I was quite sure that I had given the tonal values their due and made the buildings look as solid as they should. I particularly made sure that the white water of the fountains stood out against darker backgrounds. As in any landscape, the elements further away – in this case the buildings – are less defined than those closer to the foreground.

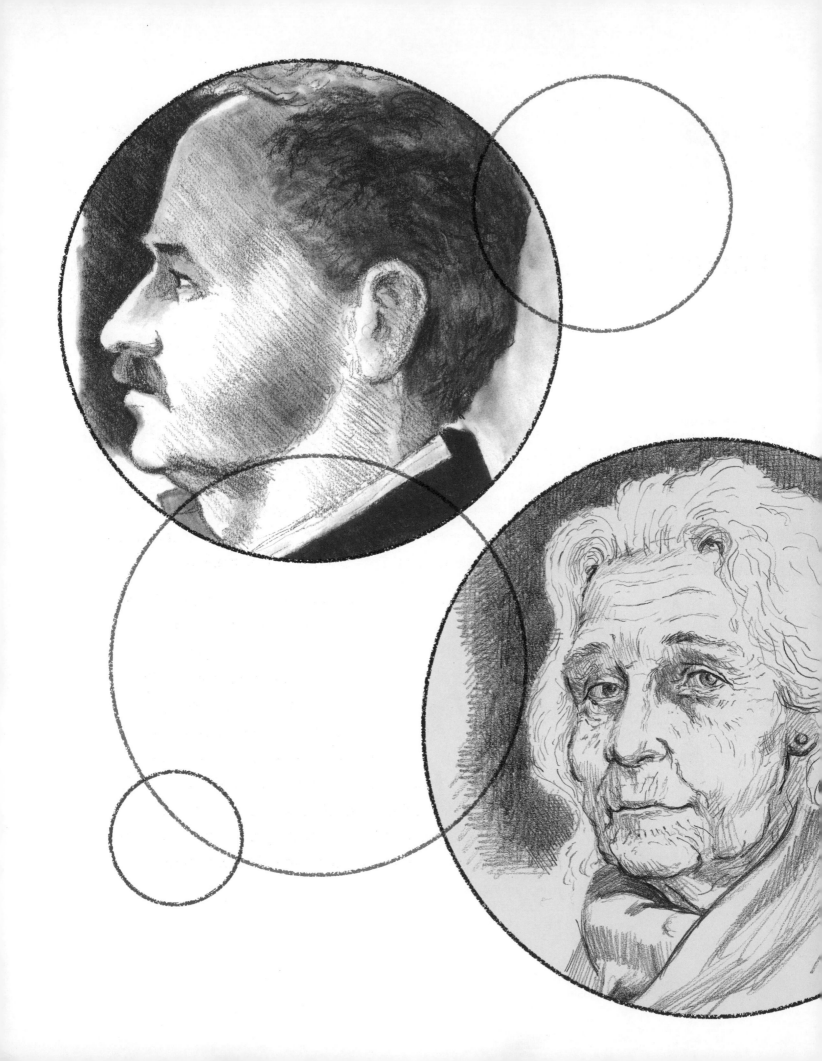

PROJECT 7: INDIVIDUAL PORTRAIT

Portraiture is a form of art that's fascinating for both artist and viewer. Catching someone's physical likeness is a particular skill, and managing to convey something of the sitter's character as well marks out a great portrait from a merely good one. No one will know whether you have produced a still-life set-up accurately, but your portrait subjects and their acquaintances will certainly have a view as to your degree of success. Consequently, there's an inherent challenge to making a portrait that's satisfying in many ways.

Don't be deterred if at first your portraits don't look very much like your subjects, since this field is one of the more difficult ones for a drawing. Keep at it, and with practice and hard work you should eventually be able to produce good likenesses of your sitters. The main thing is to be as objective as you can about the person you are drawing and follow the same method of observation you would use if you were depicting a pot or a flower, which you probably feel confident about by now. This section starts you off with very simple drawings of the head and the main shape of the figure, to make things easy for you before studying how the proportions of the face and body change when they are viewed from different angles.

Angles of the head

Before you embark on a portrait, it's a good idea to try out different angles of the head first to see how you want to draw your sitter. In most cases you'll need to show the face clearly so that your sitter can be easily recognized, but there are several variations on just a full face.

A full-face view with the eyes level is a common approach, but you might want to show some of the shape of the nose, which can't be seen so easily from directly in front.

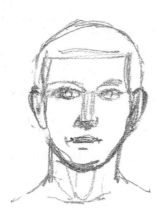

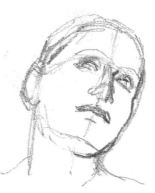

A three-quarters view with the head tilted backwards is interesting to draw, but people may not be able to recognize themselves from that angle.

The profile view is very good for the nose and the shape of the head, but of course from this angle you can't see both eyes. This tends not to appeal to the viewer.

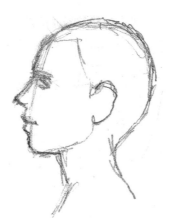

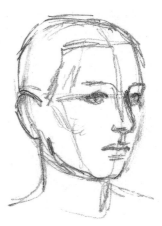

A three-quarters view with the head held level is the one used most often by portrait artists, because everyone can recognize the face and the shape of the nose can also be seen. This is why it's so popular.

A three-quarters view with the head tilted downwards can be effective, but often gives the impression of sadness.

Framing

Now you have to decide how much of the sitter you're going to include in your picture. In the first example you see only the head and neck, which is quite a good way to do a portrait because it concentrates on the face. You could draw it without much neck showing, but that gives a slightly brutal appearance.

A half-length figure with the arms and hands showing is often chosen because it helps to give a little more grace to the portrait. It's especially suitable if the model is someone who has beautiful hands or uses them for their profession, such as a pianist, a surgeon or a craftsman.

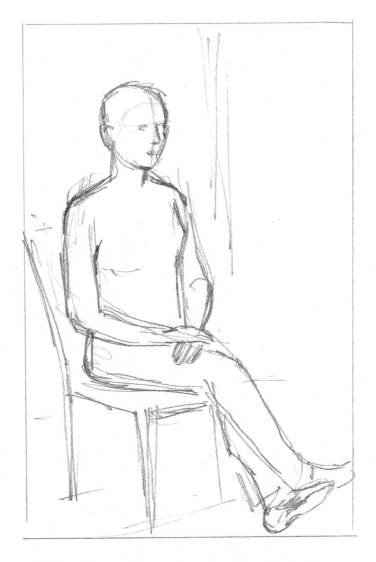

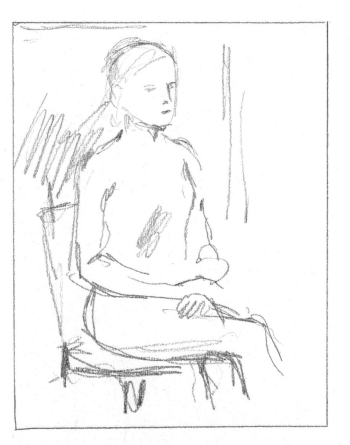

A full-length portrait would include every part of your model, but because the head becomes less significant, a three-quarter length is more commonly used.

Portraits: different approaches

While a portrait should resemble the sitter in some way, that doesn't mean it must be time-consuming and full of detail. On these pages we shall consider several examples of portraits that approach the subject in different ways before embarking on a short portrait project.

The first one is of a girl who was busy drawing in one of the classes I used to teach. There wasn't enough time to get much in, so I concentrated on the eyes, nose and mouth and merely sketched in the chin, forehead and hair.

The next subject was unable to sit for long, so once again I drew the main features of the face and just indicated the rest of the head. Notice how the background tone that shows up the profile clearly is just as important as the face itself.

These two drawings are also of people who were engaged in some other activity but sufficiently motionless for me to sketch in the face and head and, in the case of the girl on the left, the hands too. I included these because they gave a completely different feel to the final drawing.

You've probably noticed that so far none of these subjects is looking at the artist while they're being drawn. It's often easier for people not to face the artist because it can be rather disconcerting to be stared at so directly and for quite some while, too.

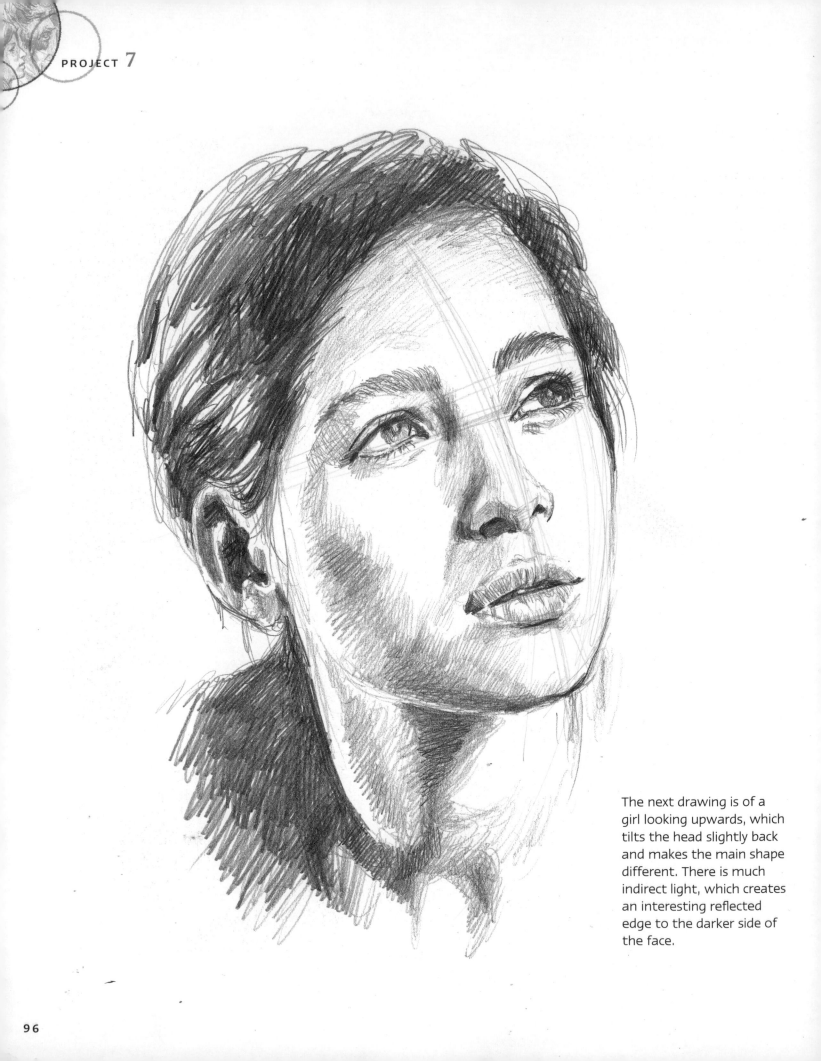

The next drawing is of a
girl looking upwards, which
tilts the head slightly back
and makes the main shape
different. There is much
indirect light, which creates
an interesting reflected
edge to the darker side of
the face.

This portrait is a complete profile view of a man's head, with a strong dark background behind the face and a lighter one behind the back of the head. Profile views were very popular in the early Renaissance period in Italy, and you might find it quite a good way to start drawing, as it seems easier to catch the exact shape of the face and head. However, it won't be the view that most people like to see in a portrait.

This time the model is looking downwards, and the significant thing here is the spectacles. These are often omitted from portraits as they can act as a sort of disguise to the face. Of course, if your model always wears spectacles, removing them will result in a portrait that looks less like the person that everyone is familiar with. Notice how much shadow there is on the lower half of the face, because the model's head is inclined.

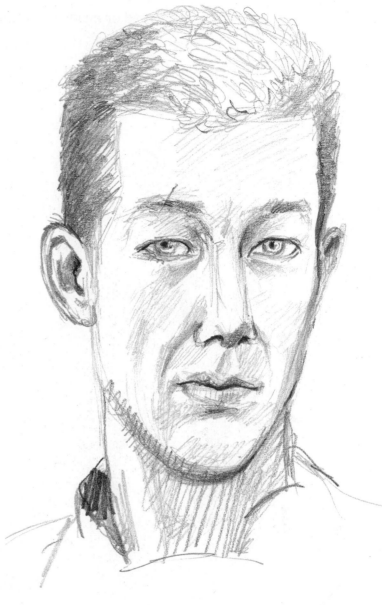

The next two drawings are both of people looking directly towards the artist, and of course this is often the best way to draw someone because it's how they are most recognizable. This man is looking almost challengingly towards the artist, and you can see that he isn't afraid to meet someone's eye.

This young boy is my eldest son, drawn when he was quite young. He found it difficult to keep still long enough for me to draw much detail, but we just about managed it. It's noticeable that he didn't look directly at me as I was drawing his eyes.

The next two drawings are full-length portraits, which are great fun to do but take a bit longer than just the head or head and shoulders. Here extra interest comes from the way in which people use their body to express their character or mood. Sometimes you may even find that body language contrasts with the message in the facial expression.

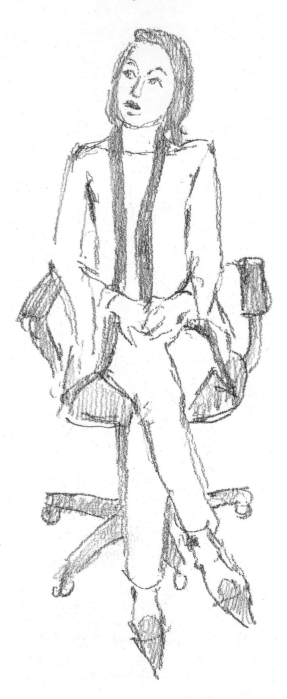

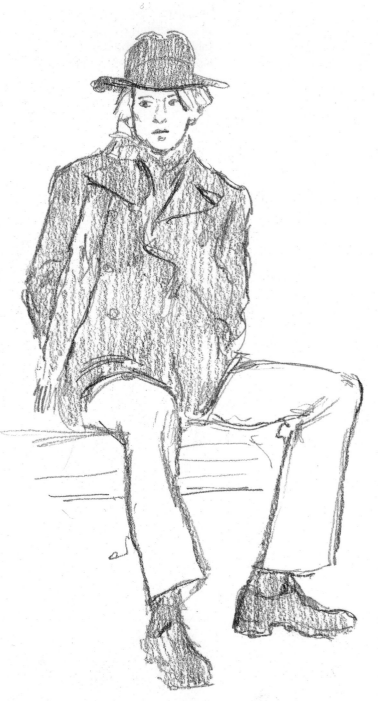

The first girl is apparently posing without being very interested in how the picture will turn out. This is from a series by David Hockney (b. 1937), and quite possibly she was only modelling as a favour to him.

This portrait is of a young man dressed in a rather poetic fashion. He looks as though he is dreaming of some interesting creation while he sits in the cold.

The next pictures are of David Hockney and his parents, drawn in three different ways. My versions are highly simplified versions of the originals, just to give you some idea of the views that he took.

Here Hockney draws himself as a half-length portrait.

He draws his mother three-quarter length in a basketwork chair that seems to hold her neatly.

And then comes his father, at full length, lying back in his easy chair, arms and legs crossed, looking very comfortable and relaxed.

An individual portrait

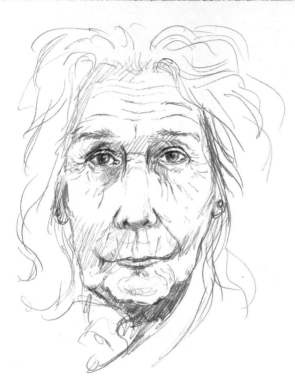

Drawing a portrait is an interesting project, for not only should the finished work look like the subject, it must also have some artistic quality that takes it further than being just a good resemblance. An elderly person's face is a real challenge, because the sitter will not be pleased if the only quality that stands out is the aged features, with their lines and loose skin. My sitter didn't expect a flattering portrait, but I felt I must not emphasize her advanced years rather than her character.

First I did a couple of drawings to acquaint myself with the forms of the face. Drawing profile, full-face and three-quarter views gave me a good knowledge of all the features that would serve me well no matter which angle I decided upon for the finished portrait.

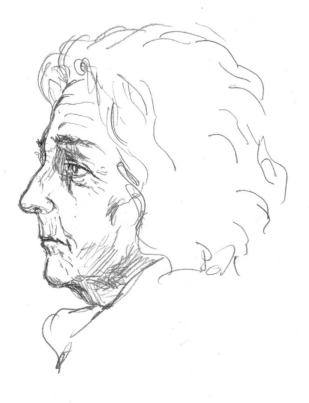

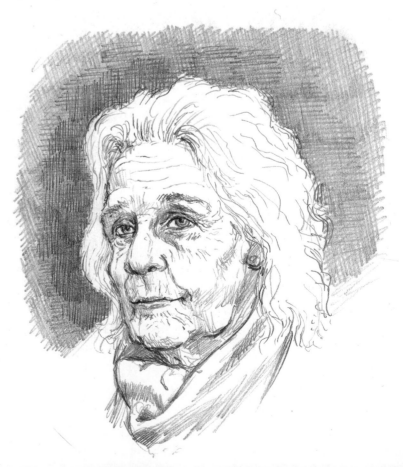

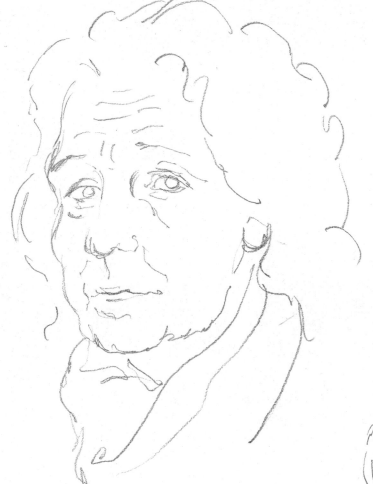

◀ I decided to use the time-honoured three-quarter view of the head, as this allowed me to draw both eyes and the shape of the nose. I started by making a very simple line drawing of the shape of the head in its entirety. If you are a beginner, it is important to make sure that you have seen the whole of the head in relation to the features – it is easy to make the mistake of getting the eyes and mouth in the wrong position on the head, which means that your drawing will not look life-like.

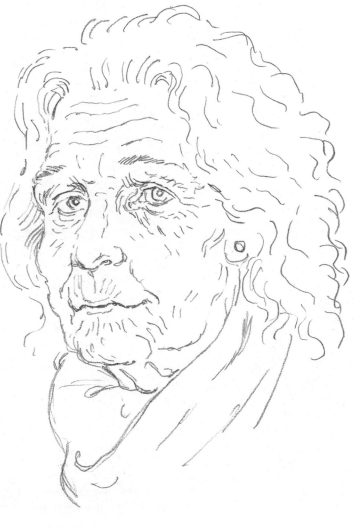

▶ I had to make sure that I didn't over-emphasize any of her lines, which were quite plentiful. The marks around the mouth and eyes were fairly obvious and the forehead had quite a few as well. As her hair was very white I didn't draw too much of it in at this stage. This kept the effect of a light surround to the face, which was appropriate.

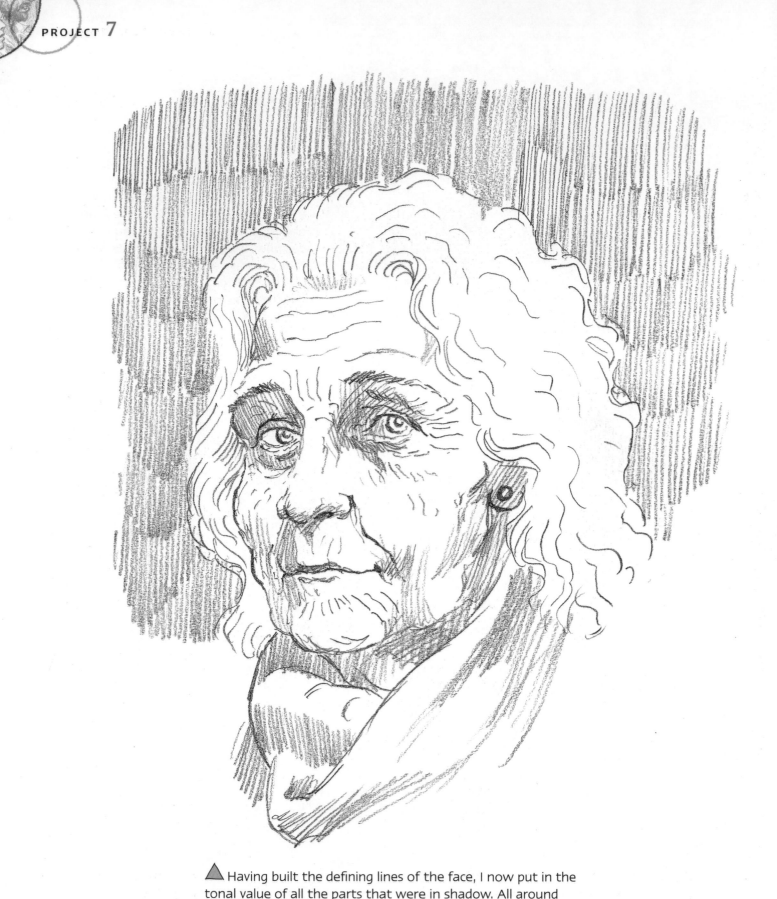

▲ Having built the defining lines of the face, I now put in the
tonal value of all the parts that were in shadow. All around
the white hair, I made a shadow which helped to emphasize
its pallor, while the shadows around the eyes and under the
chin gave a more three-dimensional form to the head. At this
stage, I kept the tone light.

When drawing elderly people you may find it useful to reduce the marks in intensity – it helps to make the form of the features look more convincing, because with age the definitions fade. This particular subject had lived a long, interesting life, so indicating her character required many subtle touches that tested my ability.

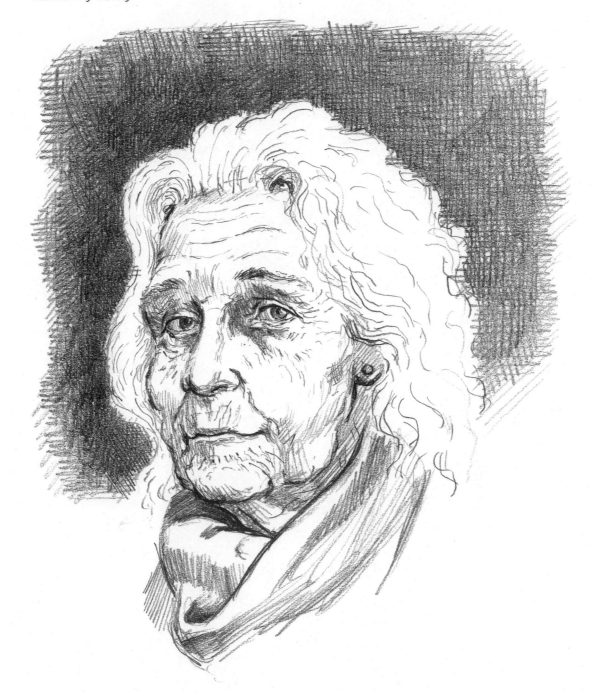

▲ Next came the last stage, in which all the final subtleties were worked into the drawing to give it conviction as a living form. At this stage it is sometimes necessary to reduce the sharpness of some of the lines on a face so that the deeper lines will contrast with the fainter ones; it is easy to overdo facial marks, which will have the effect of making the sitter look like a piece of carved wood or stone. Try softening any that you are not sure about, as you will often find it immediately improves the verisimilitude of the face.

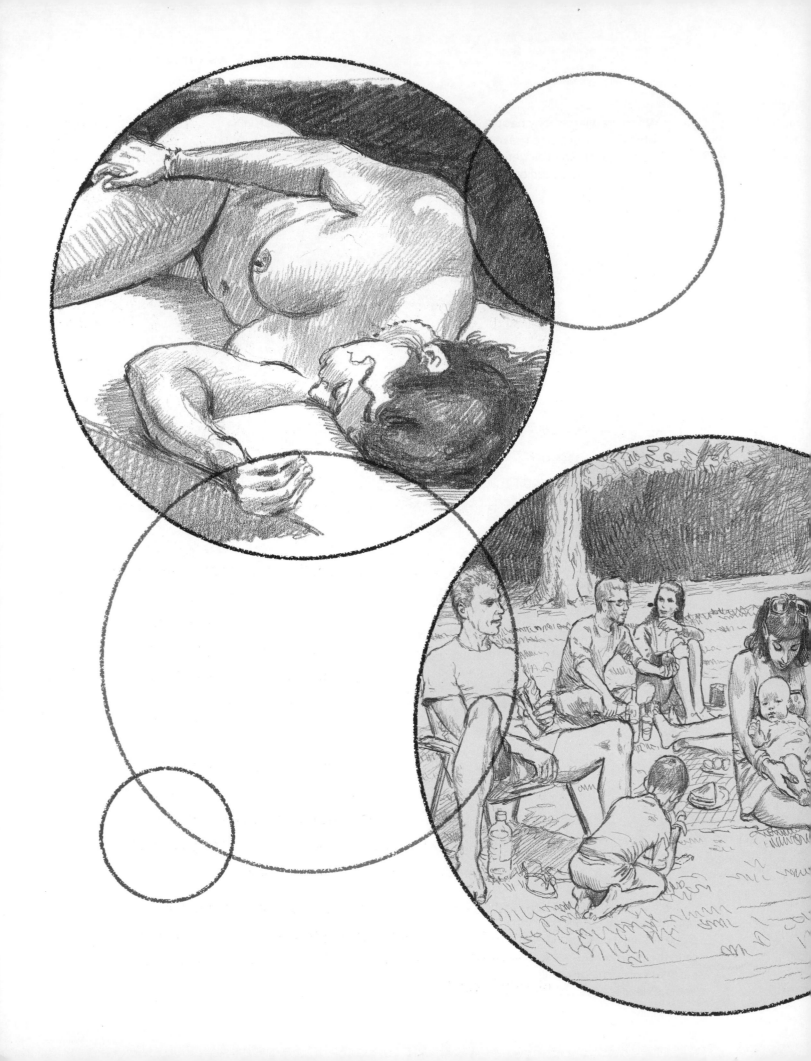

PROJECT 8: **FIGURE COMPOSITION**

Figure composition is probably the most difficult form of drawing for any artist to attempt. Not only is it technically challenging, the viewers of your work will obviously know the proportions and movements of the human body very well and will spot any mistakes. But, of course, for you as an artist there is great interest in attempting to draw a group of figures that bear some resemblance to human life.

This section starts with a reminder of the proportions of the human figure and some of the oddities that you may have to deal with in foreshortening. However, nothing is better than your own studies of the human form. Don't reject the use of photography to help here, although your own perception in studies drawn from life will ultimately give you more information than even the finest photographs.

There are many ways of simplifying the way that you look at a figure, and I have included some of them. Geometric simplification works very well in most cases. Some understanding of what goes on under the surface of a body is also very useful, and you should make an attempt to learn a little about anatomy.

The hardest thing to show accurately is movement, and there are no short cuts to observing what happens when a body is in motion. This observation is not only crucial to the artistic process but is endlessly fascinating.

Measurements

The first thing that you need to consider is the relative proportions of the human figure. This is normally drawn as if the head is a unit of measurement that goes about seven and a half times into the full length of the figure. However, to simplify this and also to produce a more attractive proportion, the ratio is often drawn as eight head lengths. Called the heroic proportion, this produces a slightly more graceful figure, typically used by the Old Masters for paintings of religious, mythical and military figures.

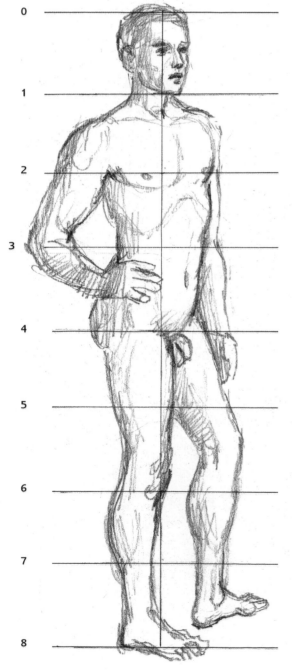

So here is a simple diagram of the figure with these proportions marked out so that you can see the effect. The picture of the female is slightly smaller than the male as this is usually the case, but the proportion is exactly the same. In actual fact there are some slight differences in proportion between the sexes, but these don't matter until you have become quite expert, and then you will begin to discover them for yourself.

The next thing to consider is that unless your model is standing straight in front of you and on the same level, the body will often appear to be foreshortened, or in perspective. This has the effect of changing the natural proportions somewhat, and as you can see in the next two figures, there is a difference in some of the measurements.

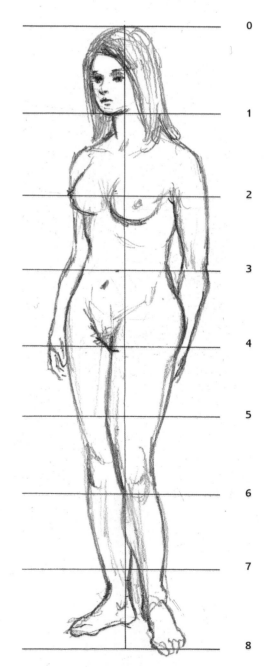

top of head

shoulders

elbows

pubic area

hands

knees

heels

When the feet are closer to you than the head, the feet and legs will look enlarged in comparison to the upper parts of the body.

heels

When the situation is reversed and the head is closer to your viewpoint, the head and upper body look much bigger than the legs and feet. You should try to work out some idea of this before you begin your drawing proper. Note the positions of the heels, knees, hands, elbows and shoulders in relation to each other. Also bear in mind that the pubic area, which is usually halfway down the figure, will appear closer to the head or the feet when viewed in perspective like this.

heels

knees

hands

breasts

shoulders

top of head

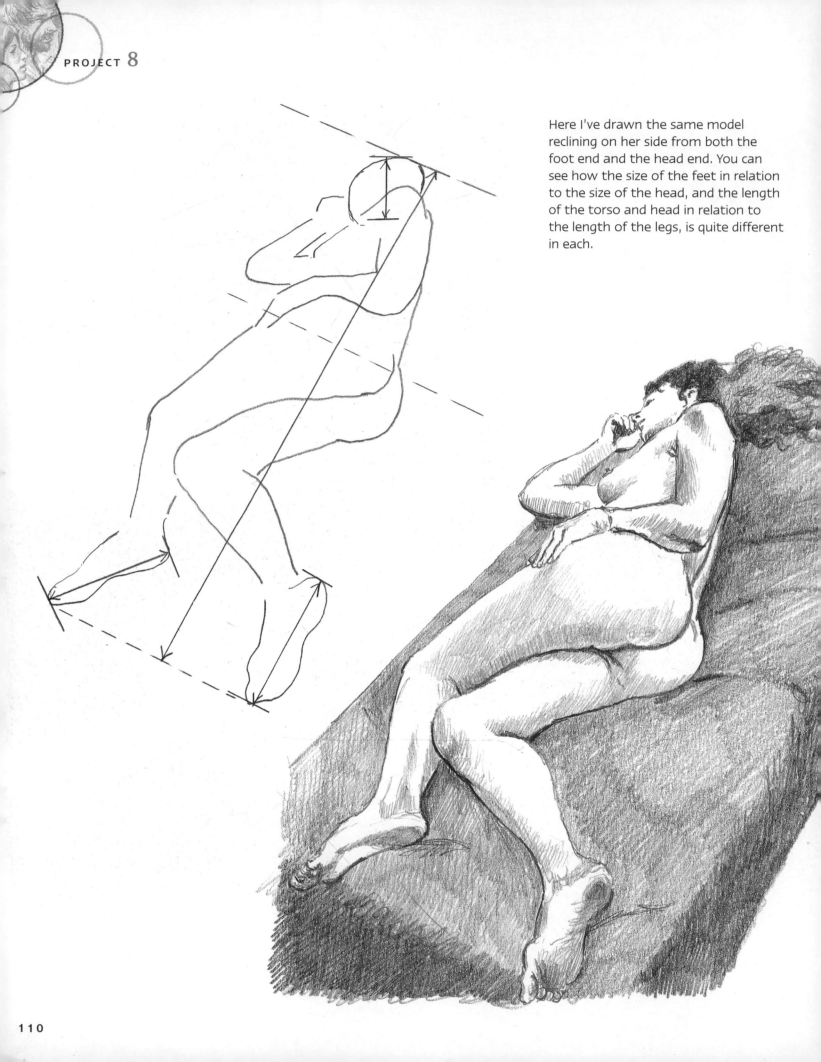

Here I've drawn the same model reclining on her side from both the foot end and the head end. You can see how the size of the feet in relation to the size of the head, and the length of the torso and head in relation to the length of the legs, is quite different in each.

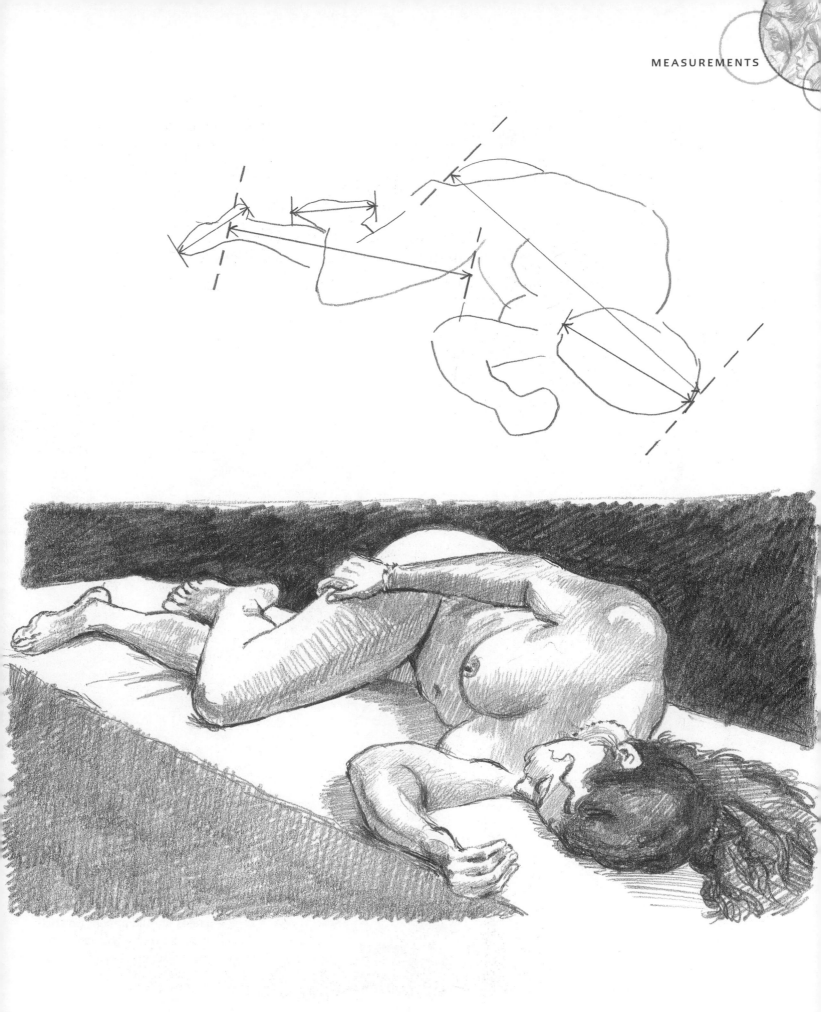

Blocking in the shape

Here we look at the figure as a whole and try to simplify the drawing by blocking in the main area as a simple geometric shape before engaging with the detail. You won't always have to do this, as once you are more proficient you'll be able to project it as a mental image. However, at the beginning it's sensible to draw the main shapes so that you're aware of the space that the figure occupies.

In the first figure treated thus (below), I've drawn a large triangle that is taller than it is wide and then marked places where I think that the shoulders, breasts and hips appear on that triangle. Putting a vertical through the centre also helps to get the feeling of the body's position.

In the second drawing (above) the model is half reclining and again she more or less fits into a large right-angled triangle with the base larger than the upright. Again I have marked in where the breasts, hips and knees should appear on this triangle to act as a check to my drawing.

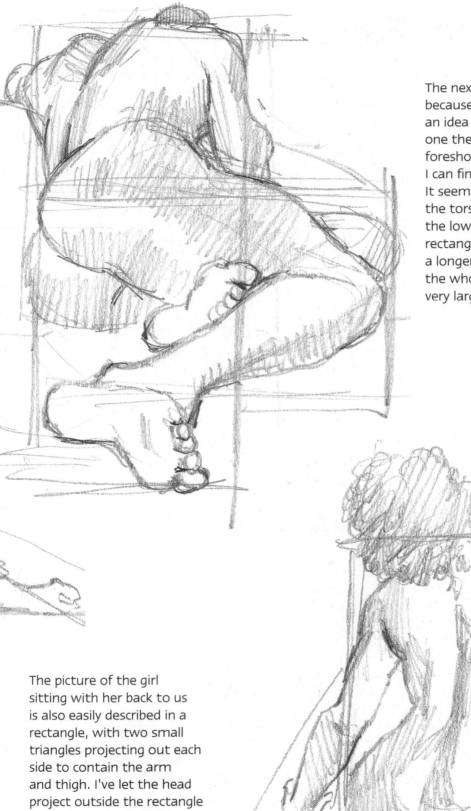

The next two drawings are a bit different, because here I've used rectangles to give me an idea of the bulk of the pose. In the first one the position of the reclining figure is so foreshortened that I need all the methods I can find to get the proportion correct. It seemed to me that the upper part of the torso and head was in a square and the lower bulk of the legs in a horizontal rectangle. If I then extended the square into a longer vertical rectangle, it would contain the whole length of the figure including the very large close-up foot at the base.

The picture of the girl sitting with her back to us is also easily described in a rectangle, with two small triangles projecting out each side to contain the arm and thigh. I've let the head project outside the rectangle without any geometric shape, because the hair is curly and doesn't have a very definite shape to it.

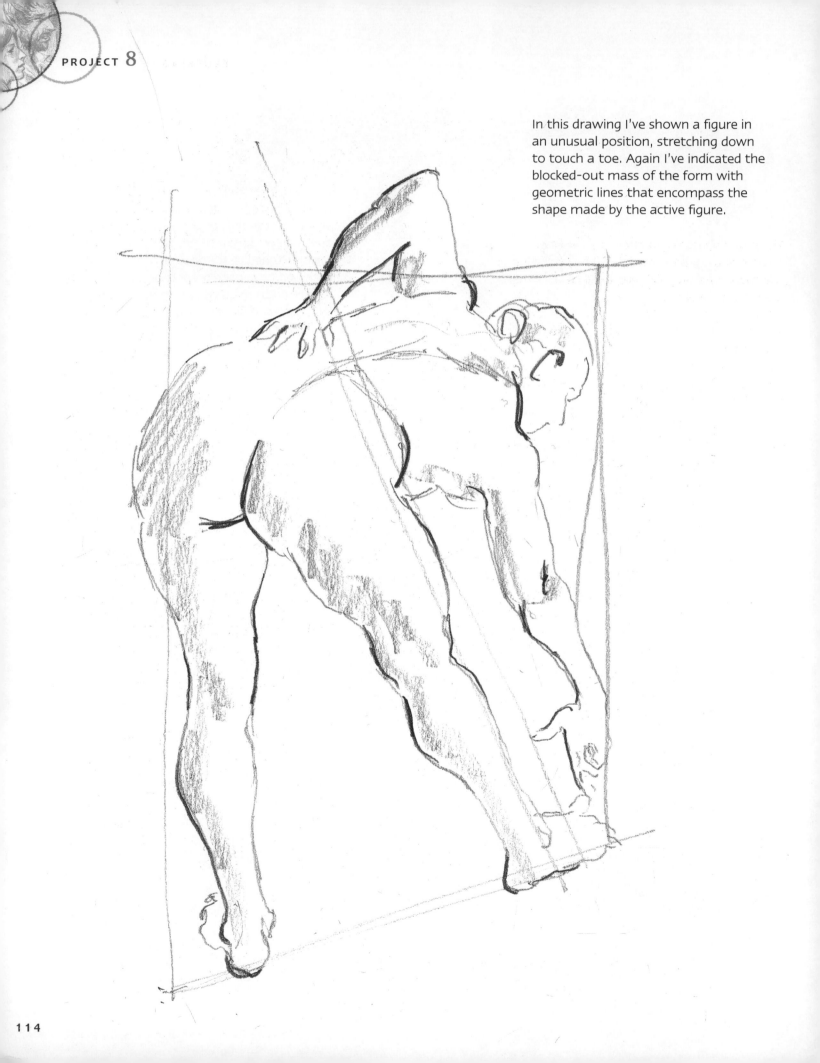

In this drawing I've shown a figure in an unusual position, stretching down to touch a toe. Again I've indicated the blocked-out mass of the form with geometric lines that encompass the shape made by the active figure.

The next two drawings show a sitting figure and a standing, bending figure, the first being in the shape of a simple triangle, while the other is a long curve with an arc and a triangle built on the arc. This triangle is also cut through with a line along the outstretched length of the leg, cutting through to the curve. This shows that the geometric shapes that encompass a figure drawing can be both very simple, or quite complicated.

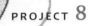

Building tone

Another way of drawing the figure so that you get some feeling for the solidity of the form is to use a system of shading that makes blocks out of the form described. The result, as you can see, gives the effect of a figure carved in wood or stone with hard edges defining each facet of the bodily form. This method helps to give depth and strength to your figure drawings, although you sacrifice subtlety in the process. It works better with a chunky or hard-looking body than it does with a more rounded form.

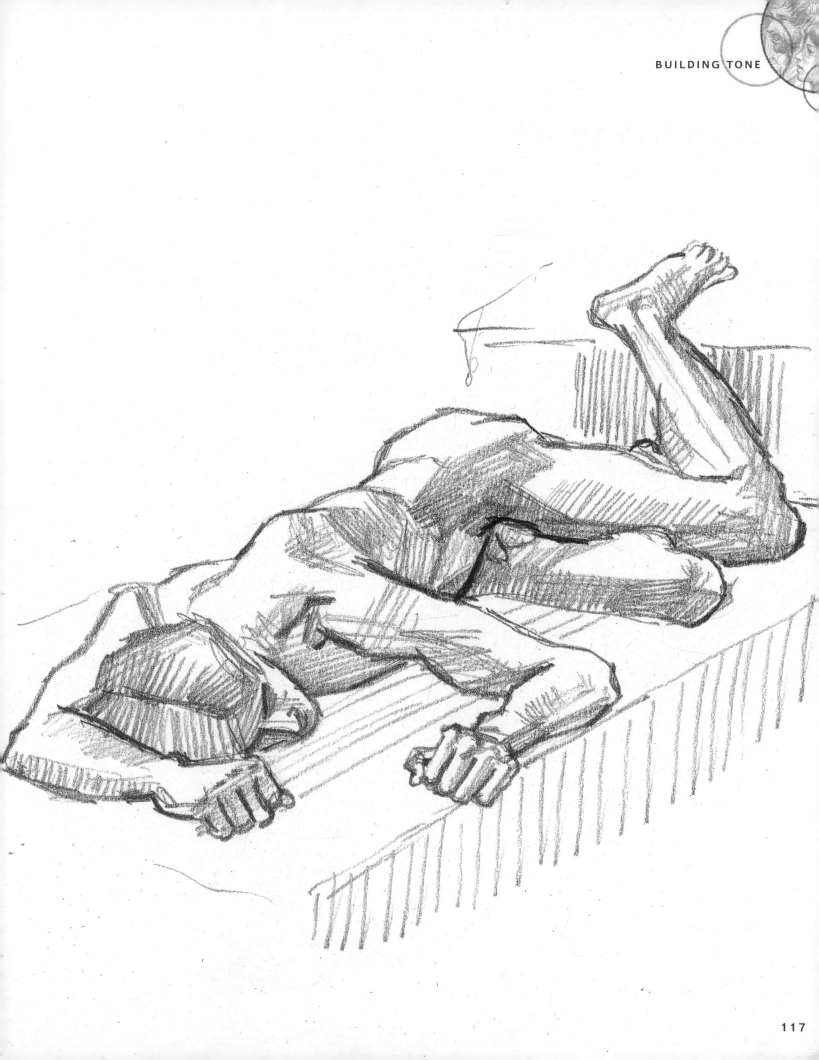

Here in the next two drawings is a more gentle version of the same process where the form is clearly defined by the use of tone, but without much variation in the tone. The resulting drama of the light areas contrasting with the darker shadowed areas makes for an effective method to show form.

The next four poses are interesting because of their natural complexity of form. This can help a drawing become a character statement as well as making interesting shapes on the paper. After all, a drawing is also an abstract shape on the blank expanse of the paper and, as artists, we are always interested in the shapes that are made. The fact that they can also tell you something about the character of the sitter is a bonus, particularly if you are dealing in portrait-type figures.

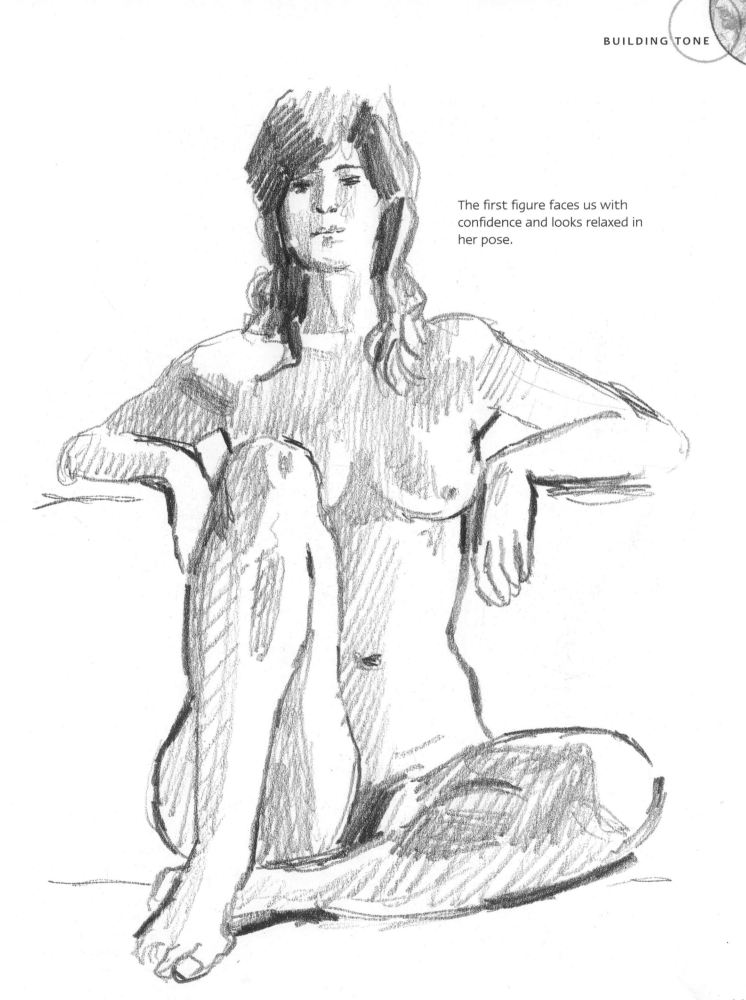

The first figure faces us with confidence and looks relaxed in her pose.

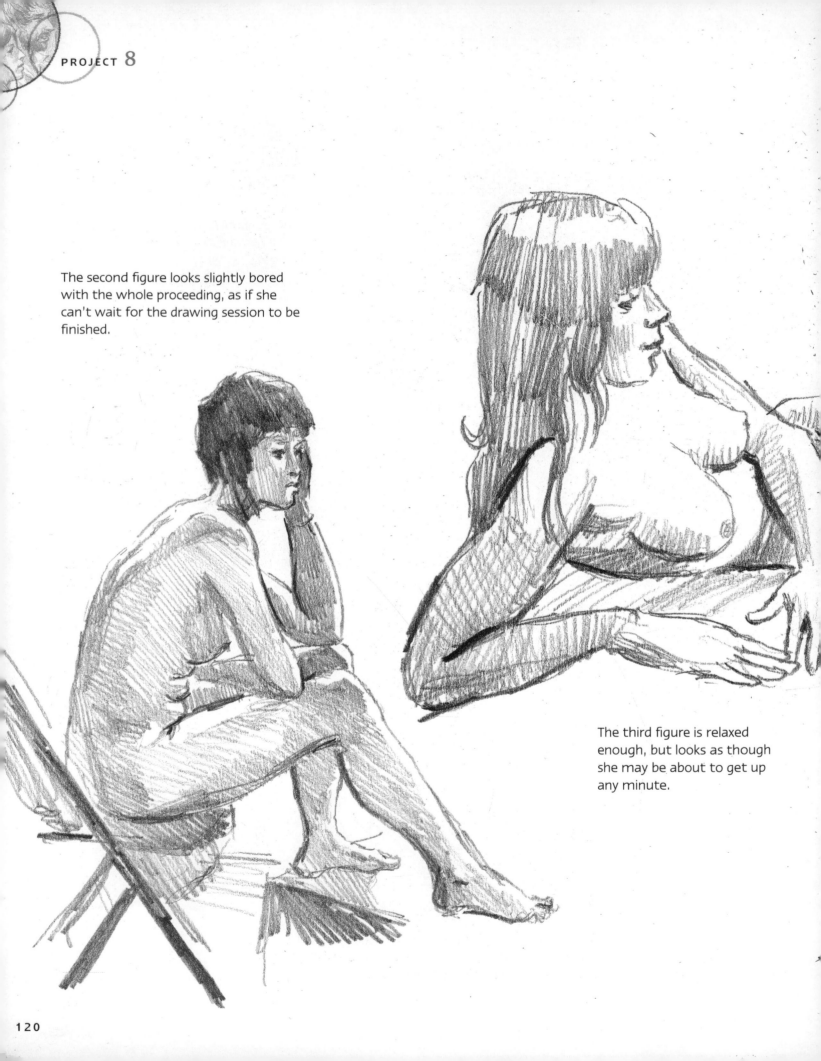

The second figure looks slightly bored with the whole proceeding, as if she can't wait for the drawing session to be finished.

The third figure is relaxed enough, but looks as though she may be about to get up any minute.

The last figure, showing her back to us, looks strong and definite.

So all these poses suggest other things than just the movement of the body in space. In a figure composition various poses are required for the overall picture to tell a sort of story. The narrative may not be clear, but it will suggest some kind of emotional tension between the figures placed in proximity to each other.

Figures in movement

When you are drawing moving figures, the most important point is to seize the moment when they are off-balance and are neither at the start of the movement nor at its end. This helps to give the effect of lively activity.

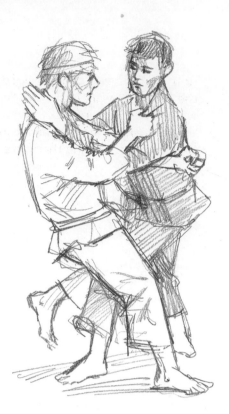

These two martial arts fighters are engaged in a tight moment when either of them might come out on top. Both are in the process of struggling with their opponent's weight and balance, and it is difficult to see who will triumph. The closeness of the composition helps to make an effective structure to the group.

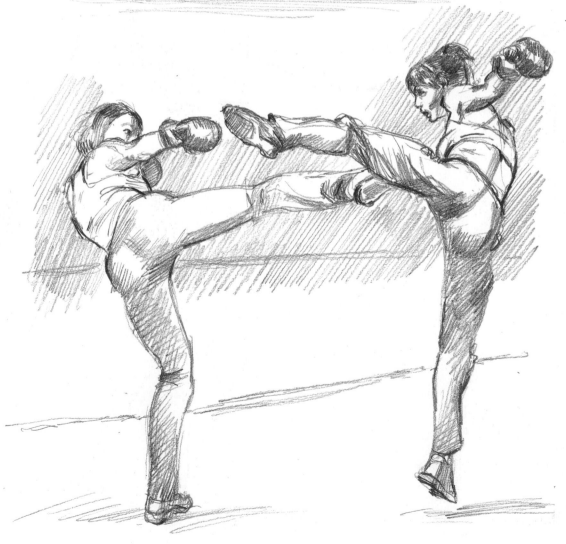

Here two female kick-boxers are in the middle of a moment of striking each other – one seems to have kicked out as the other defends herself. It is almost balletic in its intense activity and also makes a very satisfying composition for the artist.

Now we have two dancers practising that Sixties dance called the Twist. They are both swinging their bodies from side to side while keeping their feet on the ground. It is interesting to catch the moment when they are swinging in opposite directions, their arms connecting the forms as they cross over each other.

PROJECT 8

Figure composition

Drawing a figure composition is quite a test of your abilities, and it is helpful to have a theme that makes it easy to assemble a cohesive group. An interesting combination of people can be brought together at an open-air gathering, so here I have chosen the subject of a picnic.

▽ First, to develop an idea as to what I might do, I made a rough drawing of a group relaxing around a cloth spread on the ground with items of food and drink on it.

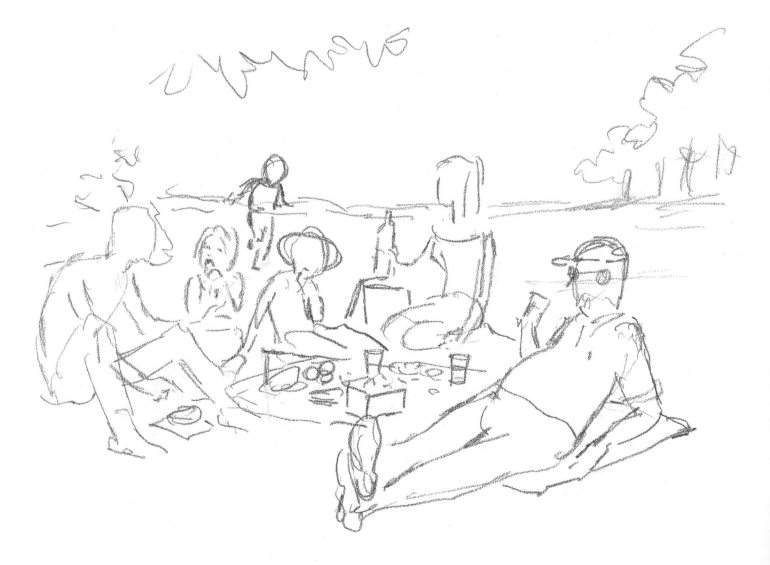

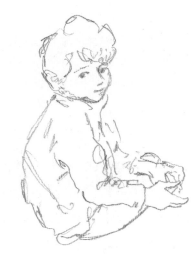

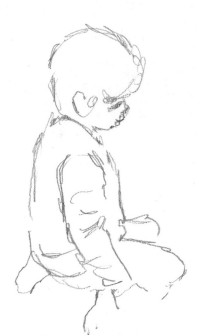

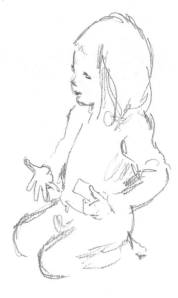

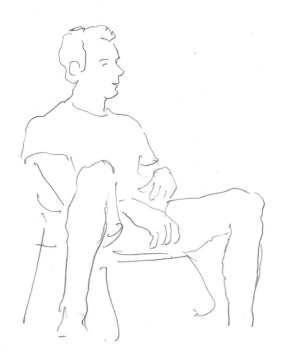

▶ Before embarking on the composition itself I drew a number of figures in typical poses for a picnic – sitting or lying on the ground, engaged in conversation or pursuing their own interests. They included children as well as adults to give me plenty of material. I knew that I would not be using all of them, but I needed enough to make my choices easier.

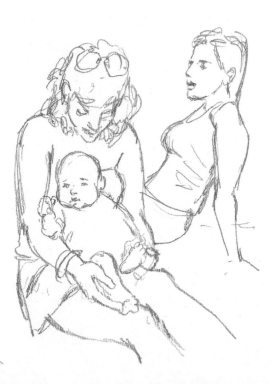

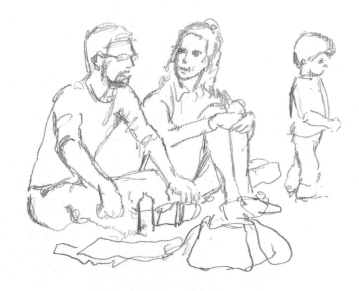

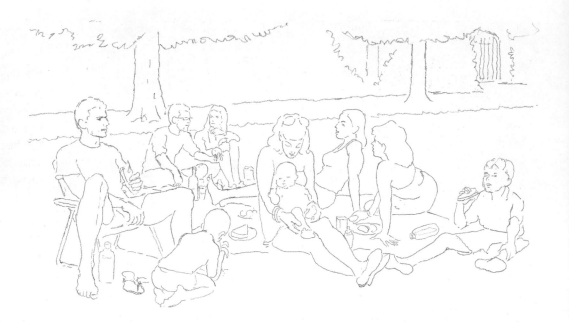

▶ Next I scribbled out a preliminary composition that spread out the figures across a space in a garden or park. This seemed a pleasingly tight arrangement and although I eventually moved everything along a bit the composition remained very much the same.

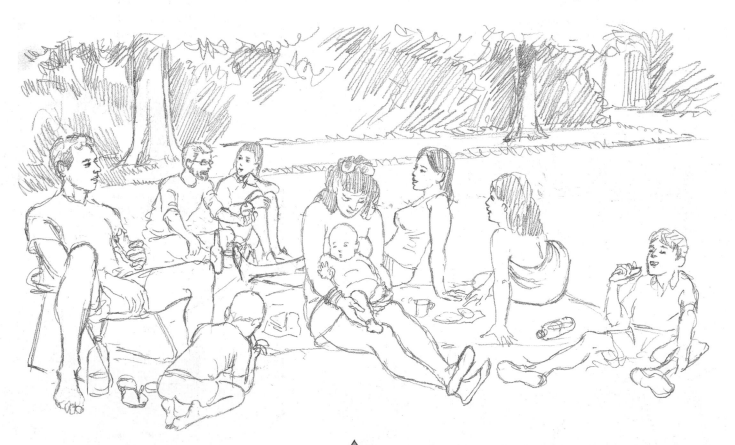

▲ Once the picture was clearly drawn up I began to put in tone to show where the sun gave shadows to the figures. I kept the tone as light as possible as I didn't want heavy tones until I was sure that the light tone worked as a whole.

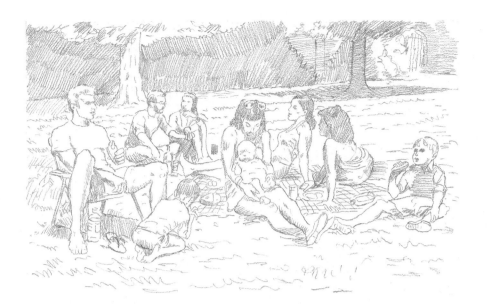

◄ The next step was to give more dimension to the scene by putting a layer of tone over all the areas where there is some shadow. This includes the background with its trees in shadow as well as the figures in the foreground.

▼ In the final stage, I defined all the subtleties of the picture so that everything started to relate in both space and form, building up the dark tones to get the most effective composition. The texture of the grass on which the figures are sitting was important in order to anchor them to the ground. This process of figure composition from separate drawings is a tough test of your abilities and you may not always get it quite right. That is what makes it so interesting, because you always have another chance to improve your skills.

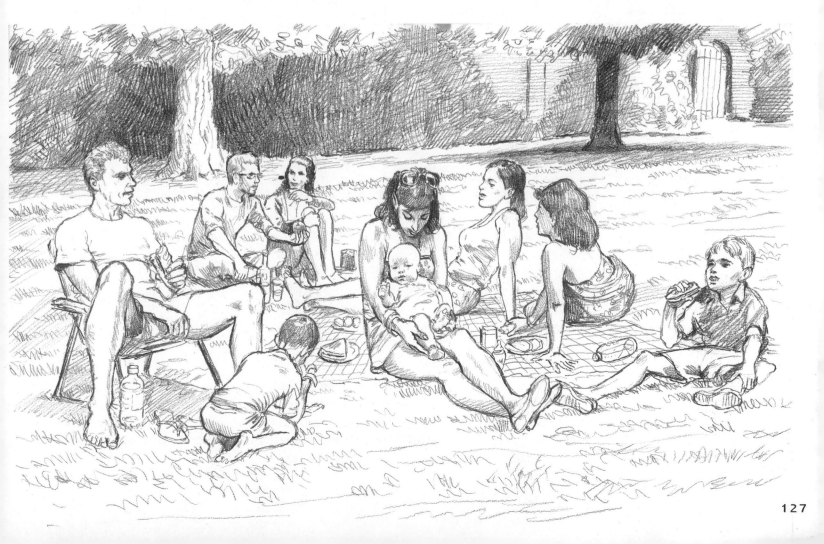